W9-BPN-140

2011

DIGITAL PHOTOGRAPHER'S

Complete Guide to HD Video

DIGITAL PHOTOGRAPHER'S

Complete Guide to **HD Video**

ROB SHEPPARD & MICHAEL GUNCHEON

LARK
PHOTOGRAPHY
BOOKS

An Imprint of Sterling Publishing Co., Inc.
New York

Editor: Kara Arndt
Assitant Editor: Frank Gallaugher
Book Design: Thom Gaines
Cover Design: Thom Gaines

Library of Congress Cataloging-in-Publication Data

Sheppard, Rob.
 Digital photographer's complete guide to HD video / Rob Sheppard and Michael Guncheon. -- 1st ed.
 p. cm.
 ISBN 978-1-60059-699-5
 1. Digital cinematography. 2. Digital video. 3. High definition video recording. 4. Digital cameras. I.
Guncheon, Michael A., 1959- II. Title.
 TR860.S453 2010
 778.5'3--dc22

 2010015765

10 9 8 7 6 5 4 3 2 1

First Edition

Published by Lark Books, An Imprint of
Sterling Publishing Co., Inc.
387 Park Avenue South, New York, N.Y. 10016

Text © 2011 Rob Sheppard and Michael Guncheon
Photography © 2011 Rob Sheppard and Michael Guncheon unless otherwise specified
Illustrations © 2011 Lark Photography Books

Distributed in Canada by Sterling Publishing, c/o Canadian Manda Group, 165 Dufferin Street
Toronto, Ontario, Canada M6K 3H6

Distributed in the United Kingdom by GMC Distribution Services, Castle Place, 166 High Street, Lewes, East Sussex,
England BN7 1XU

Distributed in Australia by Capricorn Link (Australia) Pty Ltd., P.O. Box 704, Windsor, NSW 2756 Australia

Every effort has been made to ensure that all the information in this book is accurate. However, due to differing
conditions, tools, and individual skills, the publisher cannot be responsible for any injuries, losses, and other damages
that may result from the use of the information in this book. Because specifications may be changed by manufacturers
without notice, the contents of this book may not necessarily agree with software and equipment changes made after
publication.

If you have questions or comments about this book, please contact:
Lark Books
67 Broadway
Asheville, NC 28801
(828) 253-0467

www.pixiq.com

Manufactured in China

ISBN 13: 978-1-60059-699-5

For information about custom editions, special sales, premium and corporate purchases, please contact
Sterling Special Sales Department at 800-805-5489 or specialsales@sterlingpub.com. For information about
desk and examination copies available to college and university professors, requests must be submitted to
academic@larkbooks.com. Our complete policy can be found at www.larkbooks.com.

DEDICATION

We'd like to dedicate this book to all photographers who have felt intimidated by video. We know that a book is only a start—you must spend some time working with your camera and its video capabilities in order to master it. But hopefully this book—by photographers and for photographers—will help you on your journey to learn how to shoot great video.

A book like this is only possible through the help and hard work of a lot of people. First, we'd like to thank the folks at Lark Photography Books for all of their help in getting this book going and put together. Thanks to Marti Saltzman, our editorial director, who saw the need and got excited about a book for photographers getting into video. We also would like to thank our editor Kara Arndt, who steadfastly worked on this book and made sure we stayed on track. A book about video is challenging—after all, it is a print medium talking about a moving medium—and Kara helped us focus on clarity and providing good information.

Rob Sheppard: I would like to thank Michael Guncheon for working with me on this book. Michael is a master of video technology and always has a great way of teaching. I also would like to thank my workshop and seminar participants, who helped me better understand photographers' struggles when it comes to video. And of course, I always appreciate the support and love I get from my wife, Vicky, who helps me keep going through the most difficult parts of any project.

Michael Guncheon: I appreciate having Rob as a partner in this book. Rob always keeps the focus on the image and realizes that the gear, whether it is a camera or a lens, is just a tool to capture great images. The days we have spent together, whether in an editing suite or out shooting, have been some of the more enjoyable and creative times I have spent. I would like to thank the gang at HDMG for their support both visually and emotionally; John Gleim for his golden eye regarding video compression; and Ben O'Brien and Carly Zuckweiler for their golden ears regarding the squeaky part of the picture. Lastly, I would like to thank my personal "tripod," my wife Carol, who continues to offer the greatest support, without which my life would be quite blurry.

CONTENTS

6 CREATING VISUAL VARIETY

VIDEO FOR
STILL PHOTOGRAPHERS

VIDEO FOR
STILL PHOTOGRAPHERS

Photographers today are challenged with something new in their camera—video! The addition of video capabilities for many digital cameras—especially high definition (HD) video with digital single-lens-reflex (D-SLR) cameras—makes video readily available for photographers. High-quality still photography and video functions are now housed in a single camera body. This makes video a very real and accessible possibility for more photographers.

But many photographers are also wondering, "There's video in my camera—what do I do with it?" We've put together this book to help photographers answer that question.

An important note: We know there is a lot of information in this book. Use what helps you and know the rest is there for you when you are ready. Don't expect video will be easy just because you know still photography. But also don't be intimidated by it, either. Video can be a lot of fun if you relax and just start playing with it.

THe convenience of convergence

For a long time in digital photography's brief history, there has been talk of "convergence"—bringing together video and still photography in the same camera. Small digital cameras were the first to include video, but were limited by small sensors, low resolution, a low number of frames per second (fps), and the length of time that video could be recorded—all of which resulted in poor video quality.

The biggest change is the addition of HD video to D-SLRs. This was not previously possible because the reflex mirror in an SLR redirects the light coming through the lens to display the scene to the viewfinder; the only time the sensor is exposed to light is when the shutter button is pressed. Video, on the other hand, needs light coming to the sensor at all times, but that was not possible until the addition of live view in D-SLRs. Live view means you are seeing exactly what is hitting the sensor through the lens, therefore light is able to constantly reach the sensor as opposed to being blocked by the reflex mirror. Live view (and video) was simply not possible from older technologies of D-SLR cameras. Along with other technical issues, their large sensors (compared to other cameras) meant that the camera was unable to process the images in real time and display them on the LCD or handle 30 shots per second (video speed).

Once manufacturers solved the live view challenge for D-SLRs, they could add video. Nikon and Canon were the first to do this with HD video, with other manufacturers quickly following their lead. This is a huge change for the industry, and it means that photographers can have both high-quality still photography and high-quality video in the same camera body.

VIDEO USES TIME AND SPACE

Video gives photographers new capabilities. Video depicts a scene by "taking pictures" over time rather than in one instant after the shutter is released. Video also records the natural sound available at the time of capture. Movement, time, and sound give dimension to a scene.

Still photography is limited to showing a very specific moment in time, but that limitation is also its power. Still photography allows us to look carefully at a single moment, and elevates that moment to a certain level of importance. The photographer can emphasize whatever he or she chooses. Isolating any moment out from the activity of the rest of the world gives that moment importance simply because of the emphasis that isolation gives it. Still photography asks an audience to look carefully at a single scene and what has happened there.

When a moving subject is captured on video, the emphasis is no longer on the specific moment. Instead, the action that happens over time and space becomes important. The subject is emphasized by the way it is framed, how it is followed in that frame, by the sounds that occur with the scene, and the relationship of one shot to another (video is rarely just one shot). Video requires the audience to watch what happens over time.

A single still image (below) captures a specific moment in time, while video captures a series of images over a period of time (above, right).

Movement, time, and sound expand on what the still photographer is used to. This is neither good nor bad—simply a different way of seeing the world. If you're looking for specific moments, then your attention on the world is very different than if you're looking for something happening over time. And as a photographer looks for good video to record, he or she must pay attention to sound as well. Add to that the need to capture

complementary shots that can be edited into a whole, and you can see the change in how a photographer will approach and work with a subject.

Some photographers may feel overwhelmed by this if they are approaching video for the first time—don't be. This book will help you work with the new ways of seeing with video, too, and you will find that these ways of shooting become second-nature as you explore your own video adventures.

VIDEO DOESN'T REPLACE STILL

With the addition of video to D-SLRs, many people have talked about how still photography might disappear. The argument is that if the video has high enough quality, you can take still frames out of the video rather than having to photograph those still photos separately. While that idea sounds interesting, there are some problems in actually doing it.

- Video looks its best when recorded at a shutter speed of approximately $\frac{1}{30}$–$\frac{1}{60}$ second. Still photography needs a whole range of shutter speeds—from thousandths of a second to many seconds—to do its job well.

- Still photography can work with a single image. Video needs to have multiple scenes edited together in order to work, so the videographer must be constantly thinking about interaction of scenes.

- Still photography and video are two very different ways of looking at and recording the world. They certainly have some similarities in that both types of media depend on light, lenses, and cameras to capture a visual image of the world. After that, they are really quite different, meaning that it is difficult to shoot both at the same time.

Both still photography and video are important ways to see and record the world around us. But they offer different experiences in both recording and sharing. That means that working with video on a still camera is not simply a matter of turning a dial or flicking a switch.

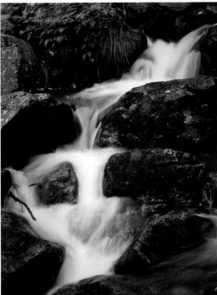

Standard video capture cannot show the blurring effects of shooting water at slow shutter speeds, nor can it stop high-speed action.

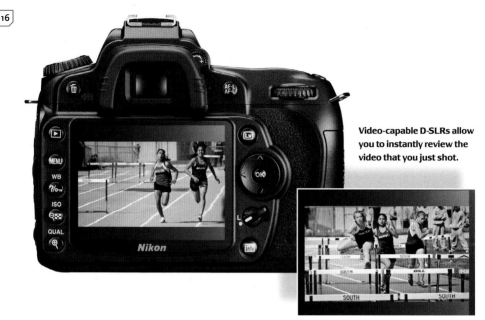

Video-capable D-SLRs allow you to instantly review the video that you just shot.

DIGITAL MAKES IT EASY

The move to digital has been an important one for photographers and videographers. Digital has made creating visuals easier, and many photographers (and videographers) are better photographers because of it. Digital technology offers photographers:

Instant Playback: Digital gives photographers the ability to see and review what they shoot as they shoot it. You can immediately see if your photograph does what you expect it to do with your subject by simply looking at playback on the LCD. You don't have to rewind anything to review a shot.

Easy Review: Digital cameras and camcorders allow you to easily review video in the same way you review still photographs. In the past, video was recorded to tape in a linear way, with one scene recorded after another. In order to view the shot you wanted to see, you had to rewind and find the spot, play it, then wind back to the end of the "exposed" or recorded tape to start shooting again. With digital, the video is recorded to memory cards, and access to that video is non-linear. You can go to any scene on the card very quickly.

Easy Editing: Digital video is much easier to work with in a computer. In the past, video editing was done with separate tape decks; editing could only be done in a linear way, meaning one scene recorded after another on the master videotape and in an order that didn't change unless you started over. This was not only limiting to how you edited, but some image quality was also lost whenever a scene was recorded from one tape to another. Linear editing also required expensive equipment, keeping video capture firmly in the professional arena.

With today's cameras, your video is on a memory card that can be plugged into a memory card reader attached to the computer. Image files can literally be dragged and dropped from the memory card to a place on your hard drive. Even if you import these files by plugging in your camera to your computer and opening some video editing software to

handle the importing, you are able to quickly see all of the scenes that you shot rather than having to constantly wind and rewind the videotape in your camera to find the right scenes to transfer to the computer.

Easy Organization: Digital video files are easier to organize than videotape. When video professionals shot videotape, they had to keep all of their cassettes carefully marked and ready for editing. They would go into playback machines as needed, then the footage would be edited onto a master videotape. This could

get very awkward and tedious. With digital video, all of your scenes are imported into the computer. You can quickly see what the scenes look like and access them immediately for editing.

Digital editing makes it very easy to change edits. You can quickly and easily remove a scene, add a scene, change the length of the scene, and so forth with video editing on the computer. All of those things were much more difficult to do when editing directly to tape where one scene is recorded linearly after another.

Digital video editing is very flexible, and one advantage is the ability to arrange and rearrange your clips in any order to suit the purposes of your film.

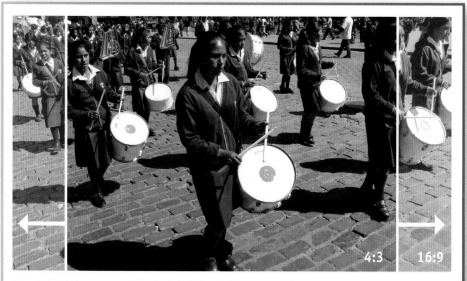

4:3 16:9

The width-to-height aspect ratio of high definition video is 16 to 9, written as 16:9, compared here with the old analog standard, 4:3.

DEFINING HIGH DEFINITION

So what is HD video? In its simplest terms, "high def" is video that has greater resolution than standard definition video; standard def is what we watched on TV for years until recently. To be more accurate, HD is high-resolution video in common use around the world with internationally agreed upon specifications. That last part is important because this somewhat universal acceptance allows high definition video to be used in many locations.

One thing photographers can use as a reference is that HD video is the equivalent of shooting thirty 2-megapixel (MP) photos a second. That's a lot of images and a lot of memory used. This is why HD video can be very demanding on computers and storage drives.

HD video is digital, but that's not what makes it HD; what makes it HD is resolution. There are two different resolutions for (or sizes) of HD video: 1920 x 1080 and 1280 x 720.

What HD is not

HD is a widescreen format—16:9—but just because you see something displayed on a widescreen display doesn't mean it is HD. In photographic terms, assuming widescreen is HD is akin to assuming an image with a square aspect ratio was photographed using a medium format camera. Maybe it was or maybe it was cropped to look square.

HD is not DTV. Digital Television is the new method of transmitting television signals that was mandated by the FCC. It is a digital transmission standard that replaced an analog system that served broadcasters in the U.S. for over 50 years. While the FCC mandated digital transmission of television channels, it did not mandate that any of those channels had to be in high definition. It just needed to be no worse than analog standard definition.

Rather than specified in terms of megapixels like digital still cameras, HD resolution is defined by pixel count horizontally and vertically.

There is another feature of video that makes it very different from still photography. When you shoot with a still camera, you might think about aspect ratio and orientation (vertical or horizontal), but you know that you aren't constrained to how the final image will be presented. You might print an image at 8 x 10 inches (20.3 x 25.4 cm) or crop it square to 8 x 8 (20.3 x 20.3 cm), or you might want create something wide like 24 x 12 (61.0 x 30.5 cm).

With HD video, your display options are fixed. HD monitors have one aspect ratio—16:9—and unless you are shooting for some special venue, the display will always be horizontal. Displays can be different sizes, from 3 inches to 300 inches (displays are measured diagonally) but they are always 16:9.

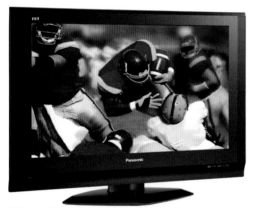

© Panasonic Corporation

© Samsung

The availability of HD displays has increased dramatically in recent years, extending the range of options for presenting HD video.

© Sharp Electronics Corporation

2

VIDEO D-SLRs vs CamCORDERS

VIDEO D-SLRs
vs CamCORDERS

There are two ways of capturing video: with a still camera that has video capabilities, or with a camcorder. We will discuss both so that you have an idea of the pros and cons of each. The equipment you use for video does make a difference, but we are not going to recommend a particular brand over another. The best camera is always the one that best meets your needs.

DIGITaL Camera ConSIDERaTIonS

First let's look at something more specific to still cameras, especially D-SLRs: mega-pixels and sensor size.

MEGAPIXELS

Video is very different than still photogra-phy in many ways, one of which is resolu-tion (or the number of pixels that make up a single still image). With photography, there is no resolution standard. In fact, there continues to be the megapixel war among manufacturers who market their cameras based on these numbers.

HD video, however, has two defined standards of resolution: 1080 (1920 x 1080 pixels), or 720 (1280 x 720). That converts to 2,073,600 pixels or approximately 2 megapixels (MPs) for the 1080 standard, and 921,600 pixels or almost 1MP for the 720 standard. (For reference, non-HD video is around 640 x 480 pixels, depending on

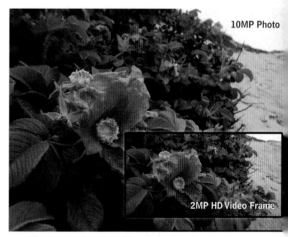

10MP Photo

2MP HD Video Frame

HD video is a relatively small image in pixel size compared to the megapixels of digital still cameras.

the broadcast standard, and converts to only 307,200 pixels—which is why it doesn't look as good). All you need is about 2MPs and you can capture the highest resolution HD video possible. You can see why megapixels aren't as important for video capture.

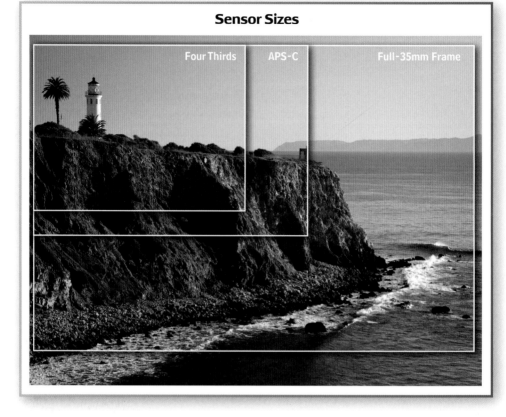

Sensor Sizes

Four Thirds · APS-C · Full-35mm Frame

SENSOR SIZE

Another misconception among many photographers is that there is a "right" physical size for a sensor, and many believe it to be to the full-frame sensor. In spite of the name, there is no such thing as an arbitrary full frame. It should actually be called a "full-35mm frame," because it is based on the size of a 35mm film negative.

There are standard still-photography sensor sizes—such as 35mm, APS-C, and Four Thirds—but there is no arbitrary quality difference among them. You cannot tell the differences among these sensors in a publication or in a print as long as the image is coming from a quality sensor with a reasonable number of megapixels (10MP or better is more than

enough) and shot with a low ISO setting. The quality of the sensor is more important than the size.

One way in which sensor size does make a difference is with noise at higher ISO settings; physically larger sensors can create cleaner images with less noise at these higher ISOs (1600 and above). This ability applies to video as well as still photos, but is only important if shooting in low light is important to you. Adding artificial light to a scene can make any clip look better with any video camera. Few pros will shoot with just existing light when light levels are low—except for some documentary shooters.

Formats with 16:9 HD Overlay (Relative Sensor Sizes)

HD 16:9 proportions fit differently into
different sensor sizes or formats.

Four Thirds

APS-C

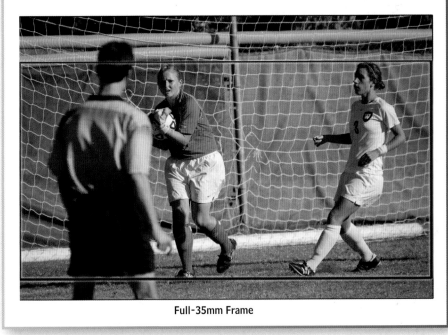

Full-35mm Frame

The sensor size also makes a difference in the size of the camera and lens, camera price, and the angle of view resulting from any given focal length. Generally speaking, a smaller sensor means you also get smaller cameras and lenses. Again, this is true for both D-SLRs and dedicated video camcorders. Also, lenses designed for a smaller sensor can be correspondingly small as well, since the projected image circle is smaller. This smaller size typically translates into lower cost cameras and lenses, but the big cost difference is that the cost of sensors goes up dramatically with size. A full-frame sensor can cost thousands of dollars more than a smaller sensor of equal quality.

Sensor size also affects depth of field, albeit indirectly. If you know anything about depth of field, you may be wondering how

a sensor—something that is not part of the optics of the lens—could change depth of field. At any given focal length, a smaller sensor sees less of the scene compared to a larger sensor—sometimes you will hear it referred to as "cropped." That means that you get an equivalent framing of a scene with a shorter focal length. For example, a 50mm lens is a moderate or "normal" lens when paired with 35mm size sensors, but it acts as a short tele-photo (75-80mm) lens when paired with APS-C size sensors, and a longer telephoto (100mm) with Four Thirds sensors. It is important to note that the focal length of the lens never changes, what changes is how it acts on differ-ent sensor sizes.

Here's where the change affects video. Shorter focal lengths give a greater depth of field, and you must use these shorter focal lengths on a smaller sensor to gain the same angle of view seen on a larger sensor. For example, a 50mm lens will give more depth of field than a 100mm. However, to get the same angle of view as a 100mm lens on a

35mm sensor, you need a 50mm lens on a Four Thirds sensor (which is half the size of a 35mm frame). The 50mm and 100mm lenses will give the same angle of view with the sensor sizes noted, but the 50mm lens is shorter, so it will have more depth of field. A smaller size sensor gets greater depth of field for equal angles of view because the focal length is always shorter.

Most small camcorders have very small sensors with lenses of rather short focal lengths. A large amount of depth of field is the norm for these camcorders. Trying to get less depth of field in order to isolate a subject can often be a challenge, though. If you are after minimal depth of field—a look that is common in Hollywood films, for example—it is much easier to achieve and control that with a larger sensor. This is a key reason why videographers have been so excited about the HD capability of D-SLRs. Previously they would have to use complicated and expensive conversion systems to achieve the limited depth of field they were looking for.

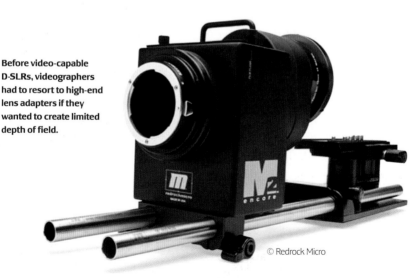

Before video-capable D-SLRs, videographers had to resort to high-end lens adapters if they wanted to create limited depth of field.

© Redrock Micro

© Redrock Micro

TERMS OF ENDEARMENT

Digital cameras use different terminology than camcorders. While digital still cameras use image sensor size terms like Four Thirds, APS-C, and full-frame—terms that still photographers recognize and understand—camcorder sensor sizes are referred to in a different way. To understand this, it helps to know a little bit about the history of video cameras.

The original television cameras used video pickup tubes to capture images. These glass vacuum tubes were cylindrically shaped, and the light-sensitive face of the tube was a circle. The size of the tube was specified as the diameter of the cylinder measured in inches or fractions of an inch.

Unfortunately with the introduction of image sensors to replace tubes, the diameter specification didn't get replaced. When you see specs on image sensors for camcorders, you still see things like ⅔", ½", or even ⅓". To give you some perspective, a full-frame sensor has a dimension of 24 x 36 mm. A ½" sensor in a camcorder is 4.8 x 6.4 mm. That is a significant difference in terms of the total image area, but remember that HD neither has nor needs the resolution of still photography.

© Canon Inc.

Feature Considerations

The following list includes requirements that you should consider when purchasing a camera for video and how to deal with features that might be missing. This list can also help decide whether a still camera with video capability or a dedicated video camcorder is the best choice for you.

CONVENIENCE

If a camera is not convenient and easy to use, then you probably won't use it. Is it comfortable to hold? Are the video features easy to access and understand? This is one area that is subjective but also very important.

Still Cameras: It is certainly convenient to have video and still photography capabilities available in the same camera. A further question, though, is how convenient is it to set up and use that video capability? This will vary considerably from camera to camera. Video in D-SLRs is still being refined as manufacturers learn how to best deal with it. You will undoubtedly see vast improvements to these cameras in the future.

© Nikon Inc.

© Canon Inc.

Camcorders: There's no question that a video camcorder is designed first and foremost for video, so all of the features tend to be optimized for video use. In addition, a camcorder is engineered as a single, compact unit. The lens is matched and carefully integrated into the camcorder's design.

FOCAL LENGTH RANGE

One thing to consider with any type of video camera is that you have access to a range of focal lengths that is appropriate for the type of subjects that you wish to record. If you want to make the next great wildlife video, you must have very long focal lengths, i.e., big telephotos.

Still Cameras: With a D-SLR, you gain the ability to use a whole range of focal lengths because you can change lenses. (The downside is that if you don't have these lenses, then you have to buy them.) Being able to choose from a lens system is an important consideration for work with video when you need specific focal lengths or types of lenses.

© Nikon Inc.

Camcorders: Nearly all commonly available camcorders have non-interchangeable lenses. Your focal length choices are thus limited to the lens that is attached to the camera. There are accessory lenses that attach to the front of the camcorder's lens to give you a wider angle of view or increase your focal length to a degree, but the effects are limited.

AUDIO INPUT

If you want to record high-quality audio with your video, then you must be able to connect a separate microphone to your camera. Good audio is just as important as the video because they are so interconnected. Bad audio can make your video "look" worse. We think that one of the most important features a camera should have is an audio input jack of some sort.

Still Cameras: This is one area that camera manufacturers have not paid as much attention to as they should. Adding even a simple microphone for video recording can make a huge difference in getting better audio. Check to make sure the D-SLR offers the abililty to connect an external microphone.

Camcorders: Most camcorders have an input jack for an external microphone. In addition, some offer more sophisticated audio features, like manual level controls.

AUDIO MONITORING

Along with the ability to add a microphone to your camera, it is very helpful to plug in earphones so that you better discern what is actually being recorded with your video.

Still Cameras: Here's another area that camera manufacturers have not given as much attention to as they should. All cameras should have this capability, but often they don't. So make sure you check the camera's audio monitoring capabilites, especially if this feature is important for you.

Camcorders: Most camcorders include a plug for headphones so you can listen to the audio that you're recording while shooting video.

QUIET

Still cameras often had video capabilities added to them without thought to how noisy the cameras or lenses might be. A noisy lens will transmit noise directly to a built-in microphone and will also be picked up by any nearby microphone. You may discover that you cannot use certain lenses with your camera because the lenses were not designed to be used with a medium that records sound.

Still Cameras: If you have a still camera, make sure you can attach a separate microphone; the built-in mic will often pick up the noise from lenses as they adjust the aperture or focus, or during image stabilization.

Camcorders: Camcorders are designed from scratch for video, so their operation and handling tends to be very quiet.

© Canon Inc.

HANDLING

Photographers often get into arguments as to what is the best camera without taking into account that the camera will handle differently for different people. Camera handling is very important with any type of photography, but it is especially so with video because you must be able to handle that camera over long periods of time as the video is recorded. This is quite different from holding the camera steady for just a few seconds while you capture a still.

Still Cameras: Still cameras are designed to be held easily in front of the face, but only for short periods of time while shooting a photograph. They are not designed to be held comfortably for the extended periods of time needed to shoot video. While some cameras are better than others for this, you may find that you need to buy some additional support equipment to help you better handle your gear.

Camcorders: Camcorders are designed for shooting video and they have had a long history of design to make them work optimally for that purpose. They are definitely more ergonomically designed for long shooting periods.

ABILITY TO CHANGE SETTINGS

Some of the early D-SLRs had the ability to shoot video, but you had very little control over the settings such as exposure or focus, especially once recording began. Some inexpensive camcorders also limit how much control you have over settings during recording.

Still Cameras: Still photographers are familiar with changing camera settings. At first, camera manufacturers simply added video to the cameras without adding the ability to change settings, so that some cameras had very little control when shooting video. They received so many compliants about this that they have worked to make cameras more controllable in all settings, including during video recording, and have released firmware upgrades to improve the video recording settings.

Camcorders: Camcorders vary in how much you are able to control camera settings. Most camcorders allow some setting changes so you can refine the look of your video, especially when lighting is difficult.

IMAGE STABILIZATION

Image stabilization was originally developed for video and has always had a strong influence there. Image stabilization makes handheld video look much, much better. It smoothes out the bumps that make handheld video shaky and sometimes hard to watch.

Still Cameras: Image stabilization works in two ways—either in the lens or in the camera body. Nearly all D-SLRs have the capability of one or the other. Both work, but it seems that the in-lens stabilization works a little bit better. That means that every lens must have stabilization for you to consistently have stabilization. If your camera has in-camera stabilization, then this is a non-issue.

Camcorders: Most camcorders have image stabilization because it is a helpful feature for shooting video.

FILTERS

The ability to use filters is an important consideration for any video camera. Polarizing filters, neutral density filters, and graduated neutral density filters all have useful applications with video.

Still Cameras: A key feature of all D-SLRs is that their lenses have filter threads. You can screw filters onto the front of the lenses.

Camcorders: Manufacturers have not always included the ability to attach a filter to the front of a camcorder lens. If you are buying a camcorder, look specifically for this feature.

TAPELESS RECORDING

The advantage of tapeless recording—i.e., recording to a memory card—is that recording is done nonlinearly. This means that you have access to any scene on the card at any time without having to rewind or fast forward. And you don't have to wind to the end of the tape to start recording.

Still Cameras: All D-SLRs record video tapelessly.

Camcorders: Camcorders will record video to tape, to optical disc (DVD), and to memory cards or internal memory. Neither tape nor disc recording is really convenient or easy to use for editing because they require extra optimization steps in the editing process.

© Canon Inc.

ADDED FACTORS

Additional factors come into play with different types of cameras.

Sensor Size: All D-SLRs use a sensor that is physically larger than the sensors commonly available in camcorders, giving you more control over depth of field than the smaller sensors in camcorders.

Sensor Count: Digital still cameras use a single sensor to capture video. While the lowest-priced camcorders also use one sensor, there are quite reasonably priced camcorders that use three: one for each color channel (R, G, and B). These improve color and tonality.

Large, Tilting LCD: Only some still cameras are equipped with an articulating LCD screen, but nearly all camcorders have a large, tilting LCD that makes it very easy to see what is being shot from a variety of viewing angles.

Rolling Shutter Effects: A D-SLR has a mechanical shutter for taking stills, but this shutter is not used when shooting video. Instead, the image sensor itself acts as a shutter. Rows of pixels are electronically blanked in sequence, rolling from the top of the image sensor down. When objects in the scene move rapidly or you pan the camera quickly, the rolling shutter effect will give a wavy look or artifact to the motion. Some describe this as objects behaving as if they were made of Jell-O. Some camcorders have a mechanical shutter to eliminate rolling shutter effects.

Optimization: A still camera is optimized to capture still pictures, not video. A video camcorder is designed specifically to capture video.

Timecode: The timecode is a time stamp that is automatically created with each digital video file. This won't affect many photographers, but for those who need timecodes for editing, some camcorders include this and most still cameras do not.

Autofocus: Camcorders offer autofocus technology that allows the camera to adjust focus while recording. Most current D-SLRs will autofocus only before you start shooting—though this is another area that manufacturers are working to improve.

© Canon Inc.

HD VIDEO TECHNOLOGY OVERVIEW

In the last chapter we discussed the two different resolutions available for HD—1080 and 720. While those two resolutions are standard around the world, there are some additional resolutions that some cameras use for image capture.

RESOLUTION STANDARDS

HD recording means a lot of data coming from the sensor—thirty 2MP images are recorded every second. In order to reduce data rates coming off from the sensor, and thus reducing manufacturing costs, some image sensors use pixels that aren't square. Instead, they are rectangular and use an anamorphic system to produce HD video.

In an HD camera that is using non-square pixels, the actual pixel count might be 1440 x 1080. When the camera records, it "squeezes" the image horizontally (anamorphic system), and when it plays back the clip, the pixels are stretched out to reform the image with the correct aspect ratio and standard pixel count— 1920 x 1080 (for 720 resolution, the numbers would look like 960 x 720 to 1280 x 720). It is a compromise, and some refer to this as not being "true" HD. But HD is not about pixel counts; it is about what you see on the screen.

HD itself is also more than resolution. There are things like frame rate, scanning, sampling, and aspect ratios. While you might just be concerned with the specifications of the camera you own or want to buy, if you want to send or display your video somewhere else, it is important that you are able to understand these ideas.

FRAME RATE

Frame rate is the number of full images per second that are captured or displayed. Frame rate was much simpler to deal with in standard definition since there were just two rates. In North America and a few other places around the globe using the NTSC broadcast standard, this video frame rate is about 30 frames per second (fps). The other worldwide broadcast system is PAL, which uses 25 fps.

Why do we say "about" 30 fps? Because when television was in its early days, frame rates were designed to be a multiple of the power line frequency coming into a viewer's home. In North America, the power line frequency is 60Hz, or 60 cycles per second. So the frame rate selected was half of 60—which is 30 fps. In Europe, the power is at 50Hz, so the frame rate is 25 fps.

When color television was introduced, the frame rate had to be slightly adjusted to allow black-and-white television sets already in peoples' homes to receive color broadcasts properly. So the NTSC frame rate was changed from 30 fps to 29.97. Within the PAL system, there was never this adjustment, so 25 frames is still 25 frames.

There is a faster frame rate available (currently for 720 resolution only) that is twice the frequency of the 29.97 and 25 fps. 59.94 fps (sometimes called 60 fps) and 50 fps are PAL-standard frame rates that offer smoother motion because the scene is sampled more times per second.

Another benefit of shooting at the higher frame rate is the ability to slow down the footage and get less blur. Most cameras that shoot 720 resolution will only offer frame rates of 23.976, 50 and 59.94 fps.

24 fps: There is another frame rate to consider: 24 fps. Most motion pictures that you see at a theater are shot at 24 fps. This has been described as a "film look," although there is more to a cinematic look than just frame rate. Since most HD video is shown on television displays that also show 29.97 fps, it is best to shoot at 23.976 fps, which converts easily to 29.97 fps.

PROGRESSIVE AND INTERLACED SCANNING

Scanning is another aspect of HD that has its roots in analog television. A TV picture is made up of rows of picture elements. In analog, these rows are called lines; in digital they are rows of pixels. Scanning describes how lines are loaded on a display or read out from the image capture device.

In order to make best use of limited bandwidth available in the early days of television broadcasts, a scanning system was developed where first only the odd-numbered lines of video were transmitted, followed by the even lines—this is called interlaced scanning. The glowing phosphors that made up the TVs would still be showing the odd lines while the even lines were being drawn on the screen. To the viewer it would look like a complete picture.

As video moved into the computer age, bandwidth limitation no longer applied, so sequential scanning, where each line was displayed (or captured) in order, was an option. This is called progressive scanning. Interlaced and progressive scanning are still used with HD video; this is shortened to "i" for interlace and "p" for progressive. 1080 (1920 x 1080) formats use either interlace or progressive; 720 (1280 x 720) formats always use progressive scanning.

HD video specs are written out with the resolution (1080 or 720), scanning type (p or i), and frame rate (29.97 or 23.976). 1080 formats can be noted as 1080p23.976 or 1080i23.976. 720 (1280 x 720) formats are 720p23.976.

CHOOSING THE BEST OPTIONS

Resolution, frame rate, scanning—what is the best option for each? That answer depends on how the HD video is displayed. If you are confident that it will only be shown on a 1080 display, then shoot 1080. Is the display progressive or interlace? These are just a few factors to consider when shooting HD video.

Most television and computer displays are now progressive. That doesn't mean they can't display interlace, it just means they have to convert the interlace material to progressive, which takes more processing time.

RECORDING MEDIA

File-based recording describes recording to memory cards as well as to optical discs, hard drives, and built-in memory. It is called "file-based" because each press of the record button on the camera creates a new file. Instead of "capturing video" to the computer (from video-tape) for editing, you "transfer" files.

With tape you don't have to archive your original footage—the videotape is the archive. Generally the cost per minute for storage is cheaper with tape. But tapes can be damaged, have dropouts caused by dirt on the tape, or might need to be captured by the computer for editing. Tape-based camcorders also have more moving parts, which require more maintenance and have more that can go wrong.

Files, on the other hand, need to be archived or backed up. If you delete the files they are gone forever, you don't have a tape to go back to if you want to recall a project. File-based systems have few to no moving parts and require less maintenance.

Files don't have dropouts, but they can be corrupted if not handled properly. Files only need to be copied to the computer, provided they are in the proper format for editing. Tape

video has to be captured by the computer in real time—four hours of footage will take at least fours hours to ingest. (Actually, it takes longer when you consider cueing up the tapes, rewinding, ejecting, etc.) Copying files can happen faster than real time and doesn't require much user attention.

CODECS

When the world was just camcorders that used videotape, we talked about tape formats—DV, Betacam, Hi-8, etc. The medium was the format. With file-based systems, the medium isn't a format. When you need to edit the file, the editing software needs to know one more thing—the codec.

The term "codec" comes from compression-decompression. A codec is a computer algorithm that is used to compress files in order to save space. Most HD files are compressed to some extent to keep them smaller, and there are a number of ways to do this. Codecs are designed for many different uses. Some are optimized for use during capture, some for use during editing, and others for distribution. There is no one universal, best codec.

There are some codecs that appear to be universal, but have different profiles or levels of quality. For example, H.264 is a codec that is used for many small web videos. Some might call it a low-end codec, yet there is a different profile of H.264 that is used in some D-SLRs that is very high quality, just like there are different levels of JPEG quality with still images.

Some people long for a camera that uses an editing-type codec that works perfectly in the computer, but the needs of a camera codec are different than those of an editing codec. For example, a camera codec needs to produce

small files, and the compression process has to happen quickly without dropping frames or using too much battery power.

Other codecs used for HD video include MPEG-2, AVCHD, ProRes 422, Motion JPEG, VC-1, JPEG2000, and there will probably be a few more before you finish reading this chapter. Some you'll find in camera systems, some in editing systems, and some in playback or distribution equipment. They all have their strengths and weaknesses , so it pays to test those that suit your needs and determine—through trial and error—whether they are worth keeping in your codec repetoire.

CHROMA SUBSAMPLING

Another part of an HD recording format is how the system deals with color. With the exception of expensive HD cinema systems, most HD cameras do not record a full RGB signal at the specified resolution. If cameras did record the full signal, the file sizes would be enormous— you'd have to change memory cards every minute and the battery life of the camera would be next to nothing.

D-SLRs don't actually capture red, green, and blue light at each photosite in an image sensor; instead, a special filter called a Bayer filter covers each photosite so that the site collects photons of just one color. The data is then converted in an image processing system to create full-color RGB pixels.

Many HD camcorders with one sensor also use this type of filtration, but there is another somewhat-similar technique used to further reduce HD files sizes. This technique is called chroma subsampling. The human eye is more sensitive to resolution in luma (the black and white part of the picture) than chroma (the

color part of the picture), so HD recording concentrates more on luma resolution than chroma resolution. HD video is usually not an RGB signal. It is comprised of a luma channel and two chroma channels, and the three channels are combined to create a full-color HD picture.

Why should you care about chroma subsampling? It does affect picture quality, so the less subsampling the better; but it works very well. When you look at the pictures, it is amazing how good they look considering how much chroma information is being thrown away. One place where it will be more obvious is in scenes with highly saturated color combinations—like red type over a blue background.

DATA RATE

One more piece of the HD puzzle is the data rate. Data rate describes how fast data is transferred through the system, and is an important bit of technical information to know. Typically it is measured in megabits per second (Mbps or MB/s). If you have two systems that use the same codec profile, frame rate, resolution, and chroma subsampling specifications, the one with the higher data rate will have the best-quality video, because it is the one with the fewest compression artifacts. Higher data rates mean larger file sizes, and require higher-performance storage devices that can read and record data at higher rates.

SOUND COUNTS

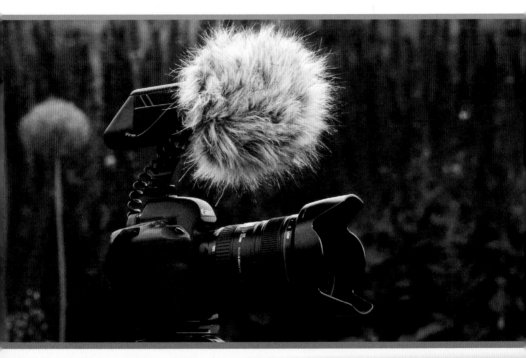

SOUND COUNTS

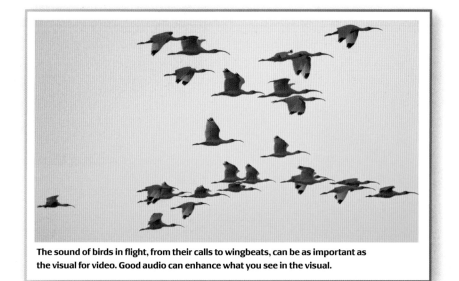

The sound of birds in flight, from their calls to wingbeats, can be as important as the visual for video. Good audio can enhance what you see in the visual.

GETTING GREAT AUDIO

The camera gets you started, but there is another very important element that you also need in order to do a good job with video—audio gear. Audio is something new for most still photographers, and is a critical part of creating good movies. It is important to know what you need for quality video recording.

SOUND AFFECTS THE LOOK OF YOUR VIDEO

We know that this may seem odd to many photographers. How can sound—or audio as it is called when recorded with video—change what a visual looks like? It does.

Hollywood knows this and uses this idea all the time. Simply changing the music playing behind a dark scene changes how the viewer reacts—the music can elicit a depressing, frightening, or tranquil feeling. The right sound effects can make a fight scene look really

brutal, comical, or even totally unrealistic. In fact, the right sound effect can add an element that isn't actually in the scene. Action TV shows often play the sound effect of a helicopter hovering when they are going after the bad guy. If you really pay attention, you never see the helicopter—they never shot it; instead the sound effect gives the illusion and saves them money.

We will talk about music later in the book, but here is a quick story about the power of audio. One time a number of years ago we were working on a video project for a client who felt that the final edited video was too slow and wasn't going to work for his corporate audience. We strongly believed the video was done right and would have exactly the effect that he wanted, but he was unconvinced. At the time, we worked with an audio engineer who was really good with music. He felt that if we just

changed the music for the program, the video would be fine. We changed the music and made only a few small edits to the video. The client saw the revised show and thought that the video moved along very well and would do the job. He thought we had done a great deal of work to the actual video, yet we had done very little other than change the music. The audio really did make the video look better.

Good audio starts when the video is recorded. If the captured audio sounds bad, it affects how your video looks; it will never look as good as it could. This can be a real problem with events. For example, if all you hear on a video are distracting audience sounds during a child's concert, the video can be painful to watch. Plus, research has shown that if people are watching a television program and the picture disappears yet they can still hear it, they are less likely to change channels than if the audio disappears but they can still see the picture.

LIMITATIONS OF THE BUILT-IN MICROPHONE

Nearly all cameras with video capabilities—whether a still camera with HD video or a camcorder—have a built-in microphone (also called a "mic" or "mike"). A built-in microphone can be helpful, but it will not give you the highest quality audio. You may also find that in some cases, a built-in microphone is actually a liability for good audio. Here are the problems with a built-in microphone:

Small and Cheap: While you will find some high-quality microphones on high-end camcorders, most built-in mics are not of the best quality. Manufacturers know that most people don't buy a camcorder for the microphone;

Built-in microphones on D-SLRs are so small that they can be hard to even see.

and in fact, most people probably don't pay much attention to the microphone at all. So the manufacturers don't put much effort into the built-in mic.

Nonselective: A built-in mic captures any sound around it. It cannot be pointed to a specific sound.

Too Far Away: Often, your subject is not close to the camera. That's fine for a telephoto lens that can visually bring the subject closer, but unfortunately this means that a built-in microphone will pick up all the sounds around you, and between you and your subject.

Camera Body Noises: Since a built-in mic is a part of the camera, it records not only external sounds, but also sounds from within the camera itself. This means that as you handle the camera, you will hear sounds made by your hands, as well as miscellaneous noises such as the lens focusing. The latter is especially true with D-SLRs. Camera manufacturers never needed to make quiet lenses for still photos. When those same lenses are used with video, noises such as focusing or zooming changes are often transmitted to the built-in mic.

EXTERNAL MICS

The solution to better audio is as simple as getting an external microphone, which is why it is so important to have a camera with a microphone jack. There are lots of options here, but we'll keep it pretty straightforward for the photographer who simply wants better sound, not audio for mastering high-quality music albums.

The two basic types of microphones that a digital photographer should consider are shotgun and lavalier microphones, but you may want to consider some other types.

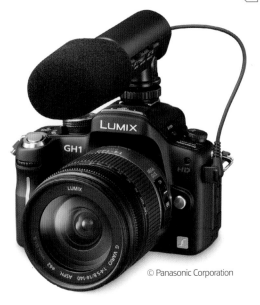

© Panasonic Corporation

Shotgun Mics: A shotgun mic is a good all-around microphone for photographers shooting video. They are easy to use, convenient, and deliver good sound. Decent shotgun mics are available for all cameras that shoot video as well as camcorders. Most fit into a hot shoe at the top of a D-SLR, or onto special hot-shoe-like mounts on camcorders. (The D-SLR's hot shoe is only used as a mount, not for any electronic connection between camera and mic.)

If a mic is attached to a camera, then it is still in the same position as a built-in mic compared to the subject. The difference, however, is that a shotgun mic limits what it records to a narrow angle directly in front of the camera. It acts more like the lens, in a sense, because it limits its field of recording to a narrower angle of the scene—even to what the lens is actually seeing. The mount of a good shotgun mic insulates the mic from the camera body so that it doesn't pick up camera sounds.

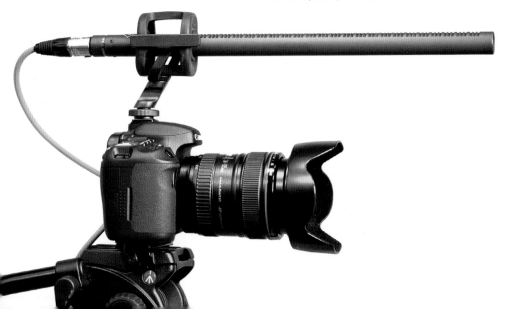

You can also take the mic off of the camera and point it directly at the sound you wish to record. You can even add a short mic extension cord so that you can mount the microphone on a stand off camera and point it at exactly what you want to hear.

QUICK TIP

CHANGE THE MIC POSITION
Sometimes poor audio is recorded simply because the microphone is in a bad position relative to the sound, whether that is a person speaking or anything else. Change your mic position to get better sound. That means aiming a shotgun microphone differently or getting any other mic closer to the sound source. With a lavalier microphone, this may mean position- ing it in a different location on the subject's clothing. With a shotgun mic, this may mean pointing it at a different angle toward the sound. Sometimes getting a shotgun mic lower or higher in relation to your sound source will change the quality of that sound considerably. If your microphone is mounted on the camera, you may need to find a different camera posi- tion in order to get better audio.

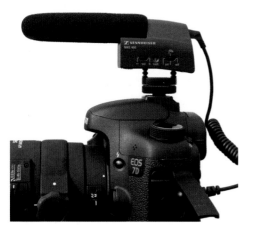

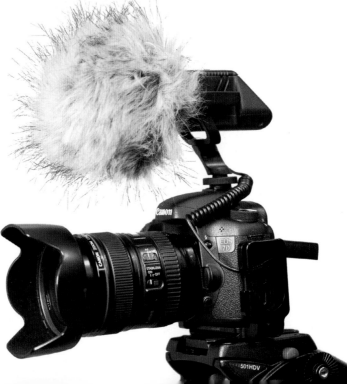

Wind can cause problems with microphones. This furry cover is designed to minimize wind noise.

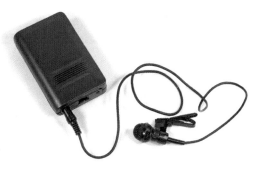

Lavalier Mics (Lavs): A lavalier is a small mic at the end of a cord that is usually clipped to someone's clothing close to their mouth. Because the microphone is so close to the person, the audio of that person talking is excellent. It picks up less extraneous sound because other sounds are much farther away. The biggest problems with lavalier mics are where to clip them on the person's clothing, dealing with the cord, and how to record other sounds away from the microphone.

Wireless Mics: A wireless mic can be any type of mic, such as a shotgun or lavalier. The wireless part simply means that the microphone is attached to a transmitter that sends the audio signal wirelessly to a receiver attached to the camera. The advantage of a wireless mic is that you don't have to have a long cord connected to the mic and you can put it practically anywhere. The disadvantages are that wireless mics can be unreliable in certain circumstances, and the transmitted audio can pick up noise or other interference that degrades the sound.

Stereo Mics: Stereo mics use two elements to pick up sounds. One part of the mic records sounds to the left and one part records to the right. This gives a feeling of stereo; however, it really isn't anything like a true stereo effect because the mics are so close together. True stereo audio is recorded with separate mics spaced at a certain distance apart from each other.

QUICK TIP

USE A LAVALIER MIC FOR PEOPLE

A lavalier mic is ideal for picking up the voices talking because you can put this microphone very close to the person's mouth. These microphones can be clipped to clothing near the person's face. They can also be hidden somewhat in clothing, but that can make them susceptible to noise from the clothing rubbing on the microphone. Also, note where a person is going to be looking: if they will be talking to someone on their right, put the mic on the right lapel so there is a better chance they won't be talking "off mic."

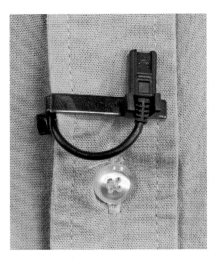

Lavalier or lapel mics usually come with a clip to attach to a person's clothing.

Handheld Mics: Some people like a handheld microphone. Television reporters typically use a handheld mic because it is quick and easy to set up, it can be kept close to the mouth so that it picks up the voice and not a lot of extraneous sound, it looks like reporter's gear and can include a station logo, and it can be pointed from one person to another. If you like doing on-camera interviews, the handheld microphone may be a good choice. It will be a very obvious part of the video, however, and will therefore give it a more formal look.

AUTOMATIC GAIN CONTROL

Most cameras and camcorders include something called "AGC" or automatic gain control. As the name implies, AGC automatically increases or decreases the level of your audio recording. If there is a loud sound, the AGC will lower the audio recording level; and if the audio is too low, the AGC will increase the audio level. AGC may or may not be included on high-end video cameras, but these usually also have the ability to manually control sound, including turning off AGC.

There are pros and cons to using AGC. If the sound being recorded is continuous, then AGC will work well. But if someone is talking and takes big pauses, for example, the pauses will go from sounding quiet with little background noise, to loud with extraneous background sounds as the AGC kicks up the volume of the mic's output. In addition, the AGC might be slow to react to drastic changes in sounds so that a person shouting may start out too loud before the AGC kicks in and reduces the level. That can be annoying and require more work to deal with that audio when you're editing your video.

Most digital still cameras with video have AGC (no manual control and no way to shut it off—though this is starting to change). Be aware of this and realize that it will increase quiet and undesired sounds when the louder sounds you are recording pause or stop. AGC can work well with adequate sound levels, but if you aren't placing your microphone close enough to the sound source, AGC will accentuate all of the background noise.

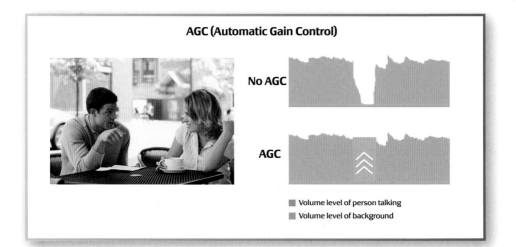

AGC (Automatic Gain Control)

No AGC

AGC

■ Volume level of person talking
■ Volume level of background

There are some workarounds to fool the AGC. BeachTek's (www.beachtek.com) D-SLR audio input adaptor embeds a high frequency tone into the audio entering the camera (the frequency of the tone is beyond the range of most people's hearing). This tone fools the AGC into thinking there is always a constant high-level signal being sent so that it never re-adjusts the audio level. JuicedLink (www.juicedlink.com) uses up one of the audio channels to fool the AGC, rather than embedding like Beachtek's adapter.

© Sony Inc.

HEADPHONES

Ideally, you should carry headphones with you so that you can listen to what your mic is actually recording. Unfortunately, most D-SLRs and other still cameras that record video do not have a headphone jack. Third party companies quickly realized the need to improve the audio capabilities for D-SLRs. You can now get adaptors that offer professional XLR connections, a headphone jack, phantom power, AGC bypasses, and manual level controls such as those offered by BeachTek and juicedLink (mentioned

QUICK TIP

CHECK LEVELS

If you are recording people talking, ask them to speak normally, do a test recording, and play it back. Don't just listen to the headphones while recording—play the clip back. This allows you to listen to the levels to make sure they are not overpowering the system and causing distortion. This also tests the recording system to make sure it is ready. Give them something to say such as asking them to say their name—if they just say, "testing one two three," it will not be at a normal speaking volume.

above). Other features include an audio meter and the ability to connect line-level audio devices as opposed to just microphones.

It is extremely helpful to be able to listen to what your camera is recording as you record it. We have a tendency to focus our hearing on things that we want to hear (that's obvious to anyone who has been at a boisterous meeting or is talking to kids). The microphone cannot do that. Sometimes it can be surprising what the microphone is capturing, but you won't know this unless you have some way to listen in on what you're recording. Headphones are ideal because they cover your ear and block out most extraneous sound. Earbuds can be used, too, if only because they are small and more likely to be carried. They are easy to keep on hand because they are compact, but the disadvantage is that they offer less in the way of judging sound quality and little to no noise buffering.

While audio is an important part of video, the storage and bandwidth requirements are so small compared to HD video that most systems provide high-quality audio recording without much trouble. There are codecs for audio that are built into each format, but it is not the codec that should be of concern. Instead, the important concepts are the number of channels that can be recorded, how they are input to the camera, and how audio levels are controlled.

The basic options for audio input are usually 1, 2, or 4 channels. There are two basic types of physical audio connections when shooting: XLR and other. XLR are professional connections that are physically strong and offer high-quality audio performance to reduce chances of hum or buzz in your audio. Non-XLR connectors are often stereo 3.5mm (also called ⅛") mini connectors that provide two channels of audio in one connection. If the cable run is not too long and the connector is built properly, you can still get good sound out of this type of connection.

Warning: There are also mono mini connectors. Be careful that you don't plug a mono connector into a stereo jack or you may end up with audio problems including no sound at all, or sound with a lot of noise or hum. Adapter plugs are available that can help.

You must also determine the level of audio signal that you are supplying. The two options are microphone level and line level. Microphone level describes connecting a microphone directly to a camera. Line level is for running the microphone through a mixer or trying to record from something like a CD player. Don't put line level audio into a mic level input—the audio will be distorted and could do some damage to the audio circuits.

Some types of microphones require a power source. Batteries are one way to get this power, but some mics require so-called "phantom power" from the recording device. If the camera doesn't provide phantom power, you won't be able to use the mic unless you use a mixer that can provide phantom power.

Once a microphone is connected, the next concern is how the camera deals with audio levels. As described earlier in the chapter, some cameras allow for manual adjustment of levels while others only offer automatic gain control (AGC). While AGC can be great if you have wildly changing audio levels, just like autoexposure it can be a compromise.

AUDIO RECORDERS

There are some reasons why photographers might consider a separate audio recorder. Solid-state audio recorders are relatively inexpensive and offer excellent audio quality for recording sound. If your camera only has a built-in microphone and no capability of adding an additional microphone, then this might be your only choice for quality audio. With an audio recorder and a good microphone, you can get the microphone very close to your sound source and be sure that you're recording only the sound that you need. Many pros shoot HD video with a D-SLR and use a separate audio recorder because they can record a better quality sound.

In addition, some photographers find an audio recorder is very helpful to record what is sometimes called ambient or wild sound. This is sound that goes with the setting or location, and is a general sound that is not specific to any specific action that is being recorded on video. You can record this sound with your camera by simply taking some quiet time to record it. Ambient or wild sound can be very helpful when you are editing video together because it can be used to link separate scenes that might have audio that doesn't match perfectly. Such sound can also be used to give a feeling about a location just from its background sound.

If you have to record sound from a specific action on a separate recorder—sound that is also being recorded on video—then you need to have some way of matching the sound from your recorder and your video. This is the purpose of a clapboard: the sound of the clapping wood was matched to the movement of the clapboard so that the sound could be synced. There are small clapboards that can be

purchased for this purpose, or you can do something like clap your hands together on video. Then when you are editing, you line up the video of the clapping hands with the clapping sound to make the audio and video sync together. Or, you can download an application for the iPhone/iPod Touch/iPad that acts as a clapboard.

QUICK TIP

CHECK SYNC AT BEGINNING AND END

If you are recording with a separate audio recording device, record a sync reference at the beginning and end of long recordings. This can be the clap of a slate or, in a pinch, a clap of your hands. Just make sure it is visible on camera. Some audio recorders can drift out of sync over long recordings, so do a clap at the end of a take also and see if it still lines up.

© Olympus Inc.

accessories
FOR BETTER VIDEO

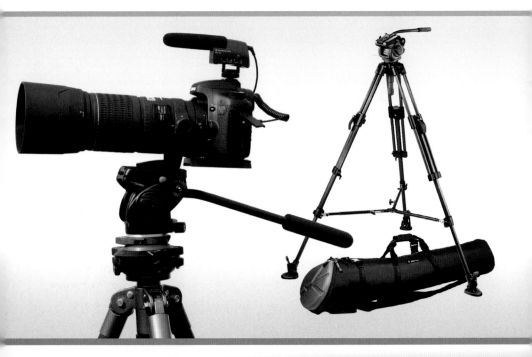

accessories
FOR BETTER VIDEO

Some of your existing photo gear may cross over into shooting video. But there are some specific tools that are designed solely for capturing video. There are a number of accessories that are worth considering that really make the recording experience its best. This doesn't mean that you need a lot of gear—it only means you need the right gear for you.

camera SUPPORT

The most important accessory for shooting video is a good tripod with a video head. The tripod head you have for still photography will not work well for video. Video has specific needs that still photography does not: the ability to move the camera during shooting and have that movement look smooth.

You can shoot video without a tripod, and people do it every day. In some situations it is the best way (or only way) to get the video you want. However, if you want to shoot the highest-quality video possible, you need to have a good tripod and video head.

Think about the differences we've mentioned between video and still photography. Video is about movement over time in single shots, and is comprised of many different shots. We've all seen videos that are hard to watch because the subject bounces all around in the frame—which makes the viewers either nauseous or gives them headaches. One of the big differences between professional and amateur video is that professional video is generally very stable. The subject movement is easy to see and understand because it is the main thing that is moving in the frame.

When the camera does move, such as panning across a scene, that movement should be regular and smooth, creating video that is easy to watch. This is not to say that all rough camera movement is wrong. Hollywood filmmakers will often use a handheld, jumpy camera when shooting action because it intensifies the emotion. However, most of the time they will use a supported camera so that the viewer does not notice camera movement.

A tripod is especially necessary for shooting video with telephoto lenses. Telephotos magnify everything—including any sort of camera movement.

In addition, a tripod makes it much easier to shoot for longer periods of time because the tripod supports the camera so that you do not get fatigued from holding it. It doesn't take long to start feeling tired when you are constantly holding a camera up to your eye—or worse, out in front of your eye—and that tiredness often gives you the shakes, making it impossible to hold the camera steady.

THE VIDEO HEAD

What makes a video head different than a still camera tripod head? The main difference is smooth movement. The tripod head used for a still camera—no matter how good it is or how expensive it is—is simply designed to hold the camera steady and make repositioning easy. Generally, there is no need to have the camera move during the exposure, so moving the head to reposition the camera doesn't have to be anything other than easy to do.

This is not true at all for video. Video requires camera movement: panning the

camera across a scene, tilting the camera up and down, or both at the same time. Any bumps, wiggles, or catches in that movement are transferred to the screen and will be very obvious to your viewer.

A video head has technology that dampens the movement and allows the camera to pan or tilt smoothly without any bumps or wiggles. This is typically done with what is called a fluid head. Such a head uses fluids and hydraulics to dampen camera movement.

Fluid heads for video can range in price from a few hundred dollars to thousands of dollars. Photographers shooting with small camcorders and still cameras do not need big, expensive fluid heads. Go down to the camera store and put a camera on a fluid head, then pan the camera back and forth while holding the panhandle of the head very gently. You should be able to move the camera back and forth without a lot of effort, and as you move the camera, you should not feel any catches or bumps, nor should the camera wiggle off the axis of the movement.

Low-priced video heads are simple fluid heads. More expensive heads can give you amazingly smooth movement of the camera, plus they often have additional features such as easily adjusted resistance (which makes for smoother movement) and the ability to balance the camera better. More expensive heads can be considerably heavier, which can be a concern if you need to travel light. Manfrotto makes some good quality, reasonably priced fluid heads.

It might seem like all you need to do is get a fluid head and simply use that for all of your photography—video and still.

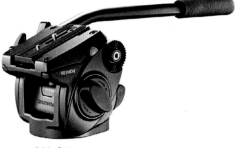
© Manfrotto

The problem with that is a fluid head is not designed for vertical shooting or quick leveling as with a typical head for still photography. You should have two heads—one for video and one for still photography.

Fluid motion aside, there is another aspect to video heads that make them different than still heads—directional movement. With most quality video heads, there will be two drag adjustments: one for horizontal movement (pan) and one for vertical movement (tilt). If you want to keep objects framed, sometimes you need to move the video camera only horizontally—as in doing a pan. By tightening the drag on tilt you can produce smooth pans while maintaining good vertical framing. A more difficult motion is diagonally, or up and down and side to side.

When you loosen a still photography ball head, the camera will freely move in all directions. Sure, there are still photography heads that allow some panning, but if you want to adjust the tilt, you end up with a loose head and uncontrolled movement. That is definitely not a situation you want for smooth camera moves.

There's also one thing missing on ball heads: something to move the head with. When shooting stills, your eye is to the viewfinder, you grasp the camera body to move it, and then lock down the head. When shooting video, you'll be a step away from the camera and you'll want to grab on to something in order to move (pan and/or tilt) the camera. Video heads usually have some way of attaching an arm (or arms) that you can use for panning and tilting the camera. Some heads come with an arm and on others this is optional.

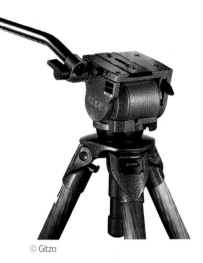
© Gitzo

QUICK TIP

SMOOTH PANS WITH A LOW-PRICED FLUID HEAD

One thing that can really help make your pan smoother is to use a longer handle on the head. Simply get a piece of aluminum tubing that fits over the handle of your existing pan handle, then cut to length to add a foot or so of extension. Attach the tube to your handle with strong tape (such as Gorilla tape). You can even make a little grip from that tape as well.

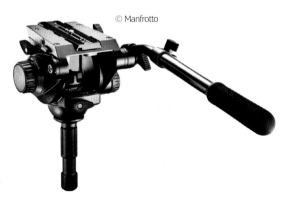
© Manfrotto

THE TRIPOD

On the surface, a tripod for still photography and a tripod for video aren't all that different. In fact, many photographers can take a quality tripod that they have been using all the time and simply replace the head with a video fluid head. This can work even if it is a little inconvenient changing heads all the time. Still, you may need two tripods—one for still photography and one for video.

We often hear complaints about the expense of tripods and heads. That's understandable; a good tripod and head are not cheap. However, a quality tripod and head are also a good investment that will last a long time. (Plus, a shaky tripod can do harm to both your still photography and video. While you might try to overcome a wobbly setup with a fast shutter speed when shooting stills, video will capture every second of those shaky moments.)

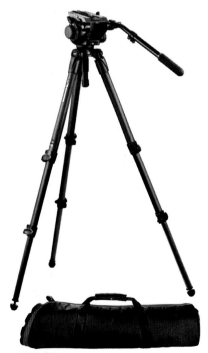

© Manfrotto

Tripods and heads don't go out of date. They will work with every camera that comes out in the future. The price of a good tripod and head is not much different than the price of a typical lens (much cheaper than high end lenses that really deserve the support of a good tripod), and less than the price of most cameras. However, the use of a good tripod and head can do more to improve video quality than buying a new camera or lens.

The tripod itself needs to be leveled when shooting video so that when you do a pan of the scene, that pan is perfectly level. You don't want to have the camera pointing flat onto the scene at the start of the pan and then have it shifting up or down at the end of the pan. Many tripods now have levels built into the collar of

TEST A TRIPOD BEFORE PURCHASE

If you aren't sure about how sturdy a tripod is, here is an easy test. Extend the legs to full height and lock them securely. Now lean on the top of the tripod and really put some weight on it. The tripod should still be stiff and sturdy and not feel at all wobbly.

the tripod just above the legs to make this leveling easier to do. In addition, opening and adjusting the legs must be easy and efficient to make leveling easy.

More expensive video tripods and heads use a ball and bowl arrangement to allow for easier leveling. The tripod itself has a bowl in the collar between the legs. The video head has a ball that fits into that bowl and includes a screw clamp at the bottom to tighten the bowl and ball together. Because of this ball and bowl arrangement, the head can be very quickly leveled and locked into place. If your head doesn't have this feature, consider buying a special adapter—a head leveler— that performs this function and fits between a normal tripod and a head.

Metal tripods are fine, but there are some big advantages for carbon-fiber tripods. While carbon-fiber tripods are definitely more expensive, we highly recommend that you look into it and get one if at all possible.

The main advantage of carbon-fiber tripods is that they are significantly lighter than a metal tripod. This is a big deal for most photographers because if a tripod is too heavy for you, you will tend to leave it at home or in the car and not use it. A low-priced tripod that you never use is a poor value. A higher-priced tripod that is constantly used is a bargain.

Our preference in tripods for photographers shooting video is a tripod made by Manfrotto or Gitzo.

Carbon-fiber tripods also have a distinct advantage in cold weather. They are not as cold to the touch when temperatures drop. That can be important when you're recording video outdoors when the weather is chilly.

OTHER SUPPORT

There are two other types of camera support that can be very useful to the photographer shooting video: a monopod and a beanbag.

Monopod: A monopod is a single leg of the tripod with a head on top. This is a very flexible way of supporting a camera. It gives you enough support so that you don't have to hold the weight of the camera all the time, and it allows you to move quickly from one spot to another with the support still attached to the camera. This makes it ideal for shooting sports because you can move with the action without having to deal with multiple legs (plus other folks around you won't be tripping on your tripod either). It does provide a lot of support for the camera, although obviously it won't give the support of a tripod because one leg is not as stable as three.

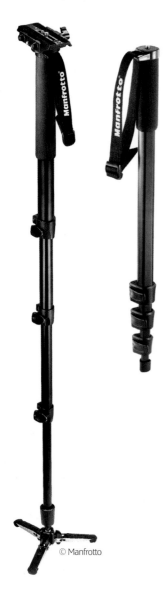

© Manfrotto

Beanbag: A beanbag is a simple and inexpensive way to support a camera. The bag is placed on a surface, then the camera is nestled into the bag, so the bag conforms to both. You can put a beanbag on almost any surface, and the flexible bag makes it easy to do relatively smooth camera moves without a fluid head.

Beanbags come in a variety of sizes and shapes depending on their end use. This also affects their weight and how easy they are to transport; however beanbags are relatively easy to transport compared to a tripod. With a beanbag, you have flexible camera support that can be used in a variety of situations.

It is very important that you have a head on your monopod. Some people try to use the monopod leg without a head and find it frustrating because you cannot tilt the camera up or down. You don't need anything fancy for a head with a monopod since you pan simply by rotating the monopod. If you want to do a lot of tilting up and down with the action, you need a fluid head of some sort.

QUICK TIP

TRAVEL LIGHT WITH A BEANBAG
For a travel beanbag, you can simply take a small, empty sack and buy dry beans when you get to a location.

Handheld Support: There are many accessories designed to support the camera's weight with your hands, shoulder, or belt. These can make handholding more comfortable and less exhausting. Anything that keeps you from getting tired holding the camera over a long period of time is very helpful, because video requires that you hold the camera steady for longer time periods than still photography.

© iDC Photography

Handheld support accessories also allow you to hold the camera steadier. They can make a huge difference in what your video looks like when you have to shoot handheld. They also steady handheld shooting so that you can gain the lively mood from shooting handheld with smoother results and definitely less bounciness that can annoy viewers.

These accessories vary quite a bit in size, complexity, weight, and price. We recommend trying them out so you can see how comfortably they fit you and your camera. Be careful about recommendations from friends or other photographers; this gear can be so unique that it will do really well with one photographer and terribly with another. It needs to fit you.

When you are shooting with your camera, pay attention to how you feel. Is the camera comfortable to shoot handheld? If not, what do you think would help? Where should the support be? Where should your hands be? Thinking about some of those questions will make it easier to evaluate if you need a handholding accessory, and what kind you should consider.

Steadicam Support: When the Steadicam was invented, it revolutionized the way that many scenes in big movies were shot. The Steadicam is an articulated arm that holds a camera away from your body. It includes many springs and adjustable controls to allow the camera to literally float without a lot of bounce or jumpiness as the camera operator moves with the camera. The Steadicam allows filmmakers to move the camera smoothly and unobtrusively through a scene as the scene takes place.

The Steadicam is an expensive device that takes a lot of training to use correctly. It is not something the average photographer is going to purchase or use. However, there are many small devices that mimic the way that a Steadicam works. Mostly they allow you to hold the camera in front of you so that the camera essentially floats free of most of your movements other than a desired movement of the camera. All of them do take a little bit of practice and some of them take quite a bit of arm strength in order to hold this camera out in front of you while shooting.

If you are considering getting a Steadicam-type device, try it out. Walk up or down stairs. Walk across a normal sort of scene at a quick pace and at a slow pace; then look at the results.

OTHER ACCESSORIES FOR VIDEO

LCD HOOD AND MAGNIFIER

LCDs on cameras today work very well, even in bright light. However, that LCD is the only way to view video with most cameras. All D-SLRs use only live view for video capture, meaning you can see what is being shot only on the LCD. Some SLR-like cameras with video capability have an electronic viewfinder, and they allow you to see video as you shoot it both through the viewfinder and the LCD. Many camcorders have only an LCD for shooting, although more expensive camcorders usually have an electric viewfinder too. Regardless, you will generally find that the LCD is easiest to use for shooting video.

The problem is that the LCD is not always easy to see in all conditions. This is why many cameras do have a separate viewfinder. An LCD hood and magnifier can take the place of a separate viewfinder in most cases. This is an accessory that we strongly recommend you consider buying. It is a hood that mounts to the back of your camera over the LCD, or it simply attaches to a flip-out LCD. It includes a magnifier to allow you to better see the LCD.

In the past, a magnifier/hood worked with video but not always that well. This was because the LCDs were of a very low resolution. When you magnified such LCDs, they looked grainy and not very clear. The LCDs on cameras today, especially D-SLRs, have very high-resolution. Using a hood and magnifier will give you excellent results. In fact, we are willing to bet that once you start using a hood and magnifier, you will find it difficult to shoot video without one.

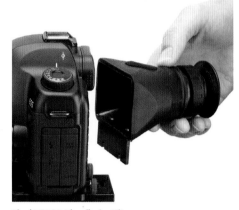

The iDC LCD Viewfinder Kit.

Hoods come in a variety of shapes, sizes, and prices. It is important that the one you choose completely covers your LCD screen. If the hood is too small, it will cut off parts of the LCD, and you will not be able to compose to the whole image area. Make sure that you can mount it securely to your camera. (We have found that the iDC LCD Viewfinder Kit which uses a Hoodman hood that has been modified with a base plate for a specific camera is a solid and very useable hood and magnifier.)

FOLLOW FOCUS

A number of companies offer devices called follow-focus controls. These mount to the camera lens and have gears which make the focus action both smoother and slower (as needed). They usually include a large knob on the side of the lens, which is easy to rotate for focus. In addition, you can actually mark the knob at the point of near focus and then again at the point of far focus so that you can change focus by simply moving the knob between those points.

Focus is critical with HD video. With standard defintion video you could get away with something being slightly out of focus, but HD reveals every little focus mistake. While camcorders have full-time autofocus built-in, and video-capable D-SLRs are beginning to integrate autofocus during video capture, the autofocusing mechanism often hunts around before locking onto a subject. Camcorders currently offer better autofocus performance—it is smoother and faster. D-SLRs may catch up soon, though better autofocus with a D-SLR will depend on SLR lens refinements. For now, manual focus may be the best solution for focusing during video capture.

Cinematographers have faced this issue with autofocus from the start. Their solution is to add a geared assembly to the side of the lens and have someone adjust focus as the camera and/or subject moves. This person—the focus puller—measures the distance with a tape measure from the film plane to the subject and adjusts the lens appropriately. For complicated camera and subject moves, this can involve many measurements.

Thankfully with the LCD we can at least see if the subject is in focus, so the tape measure isn't needed, but we still need a way of adjusting the focus without jarring the camera and causing the video to jump.

Many photographers want to experiment with creative video techniques, such as changing focus during shooting (having something sharp in the foreground at the beginning of a scene then shifting the focus to something in the background).

This technique is a lot easier with video-capable D-SLRs than with camcorders. This is because most video camcorders have a smaller sensor and a short focal length lens to match, which increases the relative depth of field. The result is that it's difficult to show a strongly shifting plane of focus. With the larger sensors of D-SLRs, and the ability to use fast lenses with large f/stops, you gain the ability to more precisely define focus in the composition.

The challenge is to be able to change focus from one part of the composition to another smoothly and accurately. Lenses for still cameras are traditionally not designed to do this. They are designed to focus quickly, which means that a small movement of the focus ring causes a noticable shift in focus. Thus, when you're trying to shift focus during video recording, a very small shift of that focus ring takes you quickly in and out of focus.

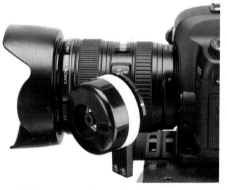

A follow-focus unit is usually a wheel against the focus ring (or zoom ring) that acts like a knob you can turn to change focus.

5

SHOOTING HD VIDEO

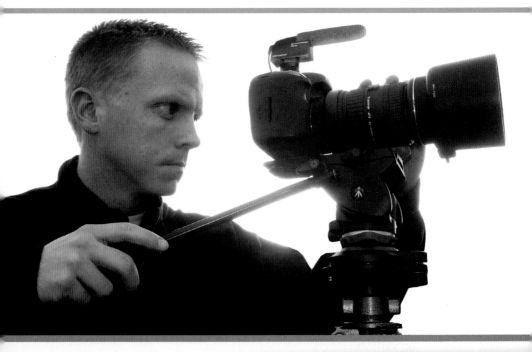

SHOOTING HD VIDEO

Now that many D-SLRs have video capability, it seems like shooting video and still photography should not be all that different. After all, the two media can now be shot with a single device. Some people even go as far as thinking that you no longer have to worry about still photography. You can simply shoot the video and take the still photos from it. This is not entirely the case.

GeneRaL consiDeRaTions

While video and still photography can be captured with the same camera, that does not mean they are the same thing. There are several important things to consider:

First, the mindset needed for shooting video differs from the mindset needed for photography. With video, you're thinking about capturing visuals, sound, or both over a period of time. With still photography, you're thinking about capturing a single image that represents one moment in time, which is a very different thing. What you capture in a video clip might not translate well into a still photo that must stand on its own.

Second, extracting stills from video will leave you very disappointed if you are used to still images with a pixel count in the 8 megapixel (MP) and above range. HD video is either 1920 x 1080 pixels (about 2MPs), or 1280 x 720 pixels (a little less than 1MP). You can't record video at still resolution, and even if the camera could do it, capturing 10MPs or more at 24 or 30 frames per second (fps) would have you swapping memory cards every few seconds.

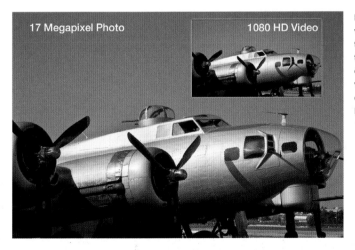

17 Megapixel Photo

1080 HD Video

Individual image files for HD video are much smaller resolution than standard digital photography. When a still camera captures video, it uses the full width of the sensor and then downsizes the file to the correct HD video resolution.

Third, video requires different shutter speeds than still photography. The optimum shutter speed for most video fits in a very narrow range—around 1/30 – 1/125 second. That's pretty limiting for still photography. For action stills, for example, you need shutter speeds that are very fast, such as 1/1000 second or faster. For a photo of moving water, generally you would use slow shutter speeds that blur the water, such as 1/2 second or longer. HD already has a built-in minimum shutter speed—the frame rate. So if you are shooting at the 23.976 frame rate, the slowest the shutter speed can be is 1/30 second.

Another consideration is that optimum video shutter speed depends on the look you are going for. 24 fps is the standard frame

Fast shutter speeds are not always possible or desirable in video.

rate for a motion picture film look (use the 1/30 second shutter speed to mimick the film look). If you aren't going for a film look and want to stop the action—and minimize rolling shutter—a fast shutter speed (1/60 second) works with a faster frame rate if you have enough light.

Slow shutter speeds for blurs are not possible in video.

EXPOSURE

Although how you choose the shutter speed might change, the basic concepts of exposure do not change when you shoot video, whether it's digital or film. You must still meter a scene (manually or automatically), to determine an appropriate exposure using ISO, shutter speed, and f/stop.

Your camera will meter a scene and give an exposure reading that it thinks is appropriate to accurately record the reflected light.

SIMILARITIES

Before we look at the nuances of video exposure, let's look at how you can use your knowledge and skill from shooting still photography and apply it to video shooting. There are several things to consider:

An exposure meter measures the light reflecting from a subject or scene and recommends an appropriate shutter speed and f/stop. This reading averages the light reflected from the scene. This means that middle tones and colors will be exposed properly. However, because the meter's logic is to expose for gray, very bright scenes could be underexposed, and the very dark scenes could be overexposed. Either instance results in a gray image.

Meters and metering systems tend to underexpose bright scenes and overexpose dark scenes as described above. This means you need to make corrections to the exposure so that the bright and dark scenes are exposed correctly.

Metering systems can also misinterpret backlight and high contrast situations, so you often need to compensate the exposure for these, too.

QUICK TIP

If you ever shoot still images with the idea that you could "fix" any problems in the computer, this will not work with video. While we are strong proponents of shooting both stills and video properly so you don't have to correct anything in post production, with video everything multiplies. Think about the amount of time you might spend in your digital darkroom on a single still image. Now consider a scene you captured that is 1 minute long. If you shot it at 29.97 fps, that means you will be dealing with a file of 1,800 individual images. Granted, video editing software doesn't make you edit things one frame at a time, but the software and the hardware still have to deal with all of those frames. This means if you have to do a lot of correcting, you may also have a lot of waiting as your computer processes (renders) all of those frames.

Overexposure washes out bright colors and tones, and loses detail in the brightest parts of an image. It can also cause significant problems with video when you are trying to edit an overexposed image into a sequence with properly exposed images.

On many cameras, overexposure warnings help keep the exposure within the proper range. This does not necessarily mean that you have a good exposure if no warnings are displayed. The picture could be underexposed.

Underexposure makes images look dark and muddy, and increases noise. It is hard to correct for underexposure in the computer for still photos, and even harder to correct for underexposed video.

Video has a limited range of optimum shutter speeds.

The histogram is a great exposure evaluation tool. It maps the tones of an image from white (on the right) to black (on the left), with the gray tones in between. One of the keys for reading a histogram is to be sure that you do not have a gap on either side of the histogram. That usually means a significant underexposure if the gap is on the right, or overexposure if the gap is on the left.

DIFFERENCES

While everything mentioned is true for both still photography and video, there are some nuances to think about that will affect exposure:

Video has a limited range of shutter speeds. As mentioned above, video shutter speeds are generally in the 1/30 – 1/125 second range. You can shoot video at higher shutter speeds, but this can significantly change the look of the video. In some cases, such as shooting action or when moving the camera quickly, this can create an unattractive stuttering look.

You aren't capturing one image, you're capturing a series of images, so you have to be careful about changing light. Video-capable D-SLRs don't handle those exposure changes gracefully. You need to either compromise on exposure settings to avoid severe over- or underexposures, or try an alternative shot.

Video is a sequence of scenes. Exposure factors into how well those scenes cut together. In order to keep scenes similar when the lighting changes, you need to change exposure. If you change shutter speed, you might change the "look" of the motion when you don't want to. If you leave shutter speed alone and change the aperture, you are affecting depth of field. Changing the ISO is an option, but higher ISO settings can increase the appearance of noise.

Exposure settings can define the look of your movie. Often, it is advisable to pick an aperture or a shutter speed for the whole project to maintain this look and then adjust either shutter speed, aperture, ISO, and lighting to maintain proper exposure.

In still photography, you can choose nearly any f/stop you like and simply balance it with the proper shutter speed. Since you can't do that in video, you are limited in your choices of f/stop.

Video is comprised of a series of images, so consistency in exposure and lighting from image to image is very important.

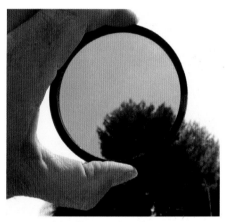

Use a polarizing filter to reduce light to the sensor when needed.

To increase your f/stop options (for depth-of-field effects), you need to find a way of cutting down the light coming into your camera if the light is bright, and using filters is the easiest solution. Many camcorders include a built-in neutral density (ND) filter for this reason.

When the light drops, you cannot start shooting with shutter speeds that are slower than the video frame rate. At this point, you can change your ISO settings (or gain settings on many camcorders) in order to continue shooting without adding light. Of course, adding light to

To reduce the light with all cameras, use neutral density (ND) filters. And ND filter is dark gray so it doesn't affect color. Singh-Ray Vari-X is a variable ND filter that can allow you to use a lens wide open for greater depth of field, even when you are in bright sunshine.

a subject will always help when the light is low, but sometimes this isn't possible. If you use a higher ISO setting, you can continue to shoot at 1/30 second, for example, and still maintain your f/stop. The downside of this is that higher ISO settings can increase the noise in your video clip. That is a tradeoff that may enable you to get a shot that you otherwise might not get.

WATCH FOR OVERHEATING SENSORS

You may have noticed various warnings in your D-SLR manual about the sensor overheating when using live view or shooting video. Not to be taken lightly, these warnings are not like the superfluous legal warnings found in many electronics instruction manuals. Pay attention to what the overheating warning looks like.

The image sensor is working very hard in video mode. Each photosite is pumping out data whether you are actually recording or not. There isn't an internal fan to dissipate heat, which is good because it would affect the audio, but this is hard on the sensor.

When shooting stills, you can operate with the camera off by just looking through the viewfinder, but with video, you need to see something on the LCD. If you are adjusting the lighting, it's easy to have the camera running for long periods of time.

Most cameras give you a warning that the camera is overheating. When the warning is displayed, you can attempt to keep recording but the image quality may suffer. Eventually the camera will shut down.

The temperatures of your surroundings can also contribute to overheating, so be aware of hot external temperatures or the effect of leaving your black camera in the sun. Pay attention to how "auto power off" is set on your camera. It is tempting to set the power off to 15 or 30 minutes when the camera is powered with an AC adaptor, but unless you really address the heat issue, you could be in for problems when you start shooting. You need to power down the camera for a few minutes.

EXPOSURE MODES

Most video-capable still cameras and camcorders give you a variety of exposure modes. These program modes typically include Program, Aperture Priority, Shutter Priority, and Manual exposure. These modes were really designed for still photography, and not necessarily designed as an integrated feature for shooting video. However, exposure modes that are built into a true video camera are designed as an integrated feature.

Regardless, don't think of exposure modes with video in the same way that you think of them when shooting still photography. There are limitations due to shutter speed restrictions for video. Unfortunately, we can only give some general guidelines as to using these modes because their implementation is different from camera to camera. Check your camera manual for more detail.

Full Auto: Many cameras include a Full Auto mode that gives total control to the camera. You cannot change anything in this mode.

Program: This setting means you let the camera set exposure for you. Both the f/stop and shutter speed are chosen by the in-camera computer to give a reasonable exposure. If you don't want to think about the exposure, this is a good way to go when you're shooting with a video camcorder. However, if you're shooting video with a still camera, check the manual to see what is possible with this mode.

The Program mode on many cameras allows you to do some tweaking to the exposure on a shot-by-shot basis.

Aperture Priority: This setting normally means that, with still images, you set an aperture or f/stop, and the camera chooses the shutter speed. It may or may not work that way with video—check your manual. You have to be very careful when using this mode with video so that you don't get an odd shutter speed that gives you results you do not like. Also, many cameras change the typical response of Aperture Priority when in video mode and you get essentially the Program mode. Check your manual.

Shutter Speed Priority: In still photography, this setting allows you to set the shutter speed you want and the camera chooses the appropriate f/stop. As with aperture priority, it may or may not work that way with video, so check your manual. This is a reasonable mode to use when shooting video. The camera is locked to a shutter speed appropriate to video, then it changes the f/stop according to the lighting conditions.

This can be especially useful if you need to shoot a specific shutter speed for the video. Sometimes people use video to analyze sports

action, for example. In that case, they often set a high shutter speed so that each individual video frame will be sharp. That allows them to analyze the action frame by frame.

Many cameras change the typical response of shutter speed priority when in video mode and you get essentially the program mode. Check your manual.

Manual Exposure: With this setting, you set both the shutter speed and the f/stop. This is a common mode for video. You often want to keep your exposure consistent as you change the camera's position during a shot, such as panning across a scene. If the camera is set on autoexposure, you may find it varies the exposure throughout the shot, which is very distracting for viewer. With Manual exposure, the settings do not change. Manual exposure makes it easy to deal with tricky lighting conditions—you can change your exposure based on a key part of the scene rather than having your meter give some sort of compromised exposure based on the entire scene.

If your camera doesn't have a histogram for shooting video, use Manual exposure to quickly take a still before you start shooting and evaluate the scene with the histogram.

QUICK TIP

To get better manual exposure, use a zoom lens and zoom in on the most important part of your scene. Set the exposure while zoomed in, then zoom out to your desired composition to take the shot. Do not readjust the exposure settings when you zoom out.

Exposure Compensation: Exposure compensation can also be used with autoexposure to better capture detail in a scene. Most cameras have an exposure compensation dial or virtual slider that allows you to give more (+) or less (−) exposure to the scene. This is important when you are shooting a scene that includes something very bright or very dark in key parts of the image.

You may need to use some sort of exposure compensation to balance the camera's internal meter interpretation of these scenes. Add exposure (+) for very bright scenes, and subtract exposure (−) for very dark scenes.

FRAME RATE AND EXPOSURE OPTIONS

Although they are both measured in units of time, shutter speed and frame rate are two separate things. Many cameras allow you to change the frame rate for video or how fast video is recorded. The standard frame rates used in HD include 59.94, 50, 29.97, 25, 24, and 23.976 fps. Choosing a frame rate allows you to change the look of the video. The frame rate options available depend on the camera and the HD resolution you are using. Currently, frame rates above 29.97 (50 and 59.94) are only available with 720 resolution.

You will find a lot of cameras allow a frame rate of 24 (or 23.976) fps. This is slightly slower than the standard video speed of 29.97 fps. But 24 fps is the frame rate at which theatrical movies are shot. When shot with a typical cinema shutter speed—typically 1/48 second—these movies have a little more motion blur than the 29.97 fps rate of video. This contributes to the "film look" for which

many video makers strive. Shooting at 24 fps helps minimize that "live TV look" of 29.97 fps.

> *Note:* Outside North America and Japan (where the standard TV video frame rate is 25 fps rather than 29.97 fps), shooters are already close to the 24 fps frame rate. Also, depending on the camera, the 24 fps frame rate maybe a true 24 fps or it maybe the 23.976 fps discussed in an earlier chapter. If you have to make a choice, the true 24 fps is mostly used only when outputting your movie to film stock to be viewed in a motion picture theater.

Slow(er) Motion: A common misconception is that faster frame rates will result in a slower playback of video, i.e., slow motion video. Unfortunately, most cameras only shoot at standard HD frame rates and the footage is played back at HD rates. There are some specialized hi-speed cameras that can shoot at fast frame rates for slow motion, but they are very expensive and may not use conventional configurations, lenses, etc.

To get slower frame rates, you usually need some specialized equipment, although this is not all that uncommon with many D-SLRs. What you need is what is called an intervalometer that takes single images over a period of time that can be put together into a video. This is basically a timing device that tells the camera how often to expose an image frame. An intervalometer can typically be set to anything from 10 per second up to a frame per minute and longer.

When these images are played back, you get time-lapse photography that shows motion sped up greatly. You can make clouds stream across the sky or show off flowers opening. You may need special software in order to put all of the individual frames together into a standard video format, but video editing software often includes this in the program.

QUICK TIP

If you are a "shoot RAW and worry about the settings later" type of photographer, you will have to change your approach when shooting video. D-SLRs do not shoot RAW video. The video is processed according to the image processing parameters that you set in the camera. You must set an accurate exposure and white balance when you are recording video.

LIGHTING

Today's D-SLR cameras have remarkable response to low-light conditions when shooting still photography. Cameras with full-frame sensors can handle low-light levels with high ISO settings quite well. Cameras with APS-C and smaller sensors are more restricted in their low-light capabilities, but keep getting better all the time.

Because of this, many photographers assume that they can get away with shooting video without extra light. This is true to a degree if the light is bright enough. However, in low-light conditions, you're typically dealing with less than optimum light on a subject. This can mean shadows in the wrong places, harsh highlights, and a lot of undesirable noise in the video. That noise—which looks like a fine texture of sand or snow—can be very distracting.

In those situations, you may need to add light. There are many excellent books on lighting for photography and video. Any good lighting book can help with video, as long as you keep in mind that an electronic flash will not work with video. For video, you must use a continuous light source.

Quartz lights are handy, easy to use lights for video, but they can get very hot.

CONTINUOUS LIGHT SOURCES

There are a number of choices when it comes to continuous lighting for video.

Quartz Lights: Probably the most common light sources used to shoot video are quartz lights (also called quartz halogen lights; see the sidebar on the next page). These lights have a standard, full-spectrum color temperature and can put out consistent light for a long time.

You can buy them specifically designed for photography and video, or you can try them out from a place like Home Depot, where they sell quartz lights as work lights. The Home Depot lights are a little clunkier, and you may have to remove a grid over the light that creates a shadow, but they can give you great continuous light for a lower price. You can always purchase lights that are specifically designed for video after you've tried the more affordable version, and you will know exactly what you want.

The downside of quartz lights is that they get very hot. This can be uncomfortable for someone sitting in front of the lights—not to mention handling the lights after a shoot—and for certain subjects, such as cold food, they can't be used at all.

QUICK TIP

Quartz Halogen

Not all quartz lights are halogen lights and not all halogen lights are quartz lights. Quartz light refers to the clear container around the light, while halogen refers to the gas inside the light. If you were to go to a lighting supply store and ask for quartz lights, you would immediately get a bunch of choices of lighting fixtures for video or photography. If you were to ask for halogen lights, you might get a quartz light, and you might get lights that are used for more general purposes. The most reliable name for this kind of light is quartz.

Fluorescent Lights: Another way to avoid the heat from quartz lights is to use fluorescents. You can now find fluorescent lights readily available for video. These lighting systems are designed for portability and travel, and can be set up on a light stand.

© Savage Universal Corporation

LED Lights: These lights have a very long life, are quite compact, are often balanced to daylight, are never hot, and are energy-efficient. They do not have the light output that quartz lights have and they are rather expensive right now, but future prices are expected to be more reasonable.

HMI Lights: You might hear or read about HMI lights used by professional video and film shooters. HMI (hydrargyrum medium-arc iodide) lights are high-end daylight-balanced lights found on Hollywood film sets. They are very expensive as well as somewhat dangerous if used incorrectly. Most photographers or videographers will not need them.

LED lights are relatively new to video. They are daylight-balanced and don't get hot, but are still expensive compared to quartz lights.

WHITE BALANCE

White balance is very important in video. This is a setting that controls how the camera reacts to the color of light. You can choose a specific white balance setting, you can set a custom white balance setting for a specific condition or you can use auto white balance (AWB).

We highly recommend that you avoid using AWB. AWB is consistent in one way: its inconsistency. This can result in compromised colors. While that is a problem in still photography, you are generally dealing with individual photos that can be corrected in the computer.

You will quickly discover that having to constantly change and match white balance is no fun when you're editing video. You need consistency between scenes so that they come together well. This means that you want to be sure that when two shots are edited together in the video, they will have a similar, if not exact, color balance. If the color is way off between them, this will cause a lot of problems. With video, the very act of editing two scenes together forces the viewer to subconsiously compare the color balance.

These two images show the importance of choosing a specific white balance. The first is shot with a specific white balance setting of daylight. The second was shot with auto white balance and has weaker colors and a bluish cast.

When setting custom white balance, be sure your white or gray neutral card fills the image area and is properly exposed.

One way to deal with this is to set a specific white balance. Set Daylight for daylight, Cloudy for cloudy, Incandescent for general indoor house lights, and so forth. If you aren't sure about the correct white balance to use, try a setting and shoot some video, then look at it on your LCD and see if it looks close to what you expect.

You can also set a specific Kelvin temperature with many cameras. This is useful when shooting in difficult lighting conditions, such as at a higher altitude in the shade. This situation results in very blue images, but by changing your Kelvin setting, you can neutralize that blue. However, you need a color temperature meter to do this accurately.

The most accurate option is to set a custom white balance. This can be very important when you are working with indoor lighting that is difficult to handle with the settings that come with your camera.

Set Custom White Balance: Setting a custom white balance is exactly the same as when shooting stills. Place a white or gray card in the scene so it is lit by the same light that will be illuminating your subject. Make sure it is not placed near a strongly colored object that could reflect onto the card.

Frame the card so it fills the scene and make sure it is properly exposed. Over- or underexposure will lead to faulty custom white balance. From this point, the process changes from brand to brand, so you may have to check your camera manual. With some cameras you need to shoot and store an image on the memory card, with others you measure the white balance by taking a temporary picture that is not stored anywhere.

Once you have set a custom white balance, make sure that you set the white balance function of the camera to the custom mode.

Take white balance to the next step. Move beyond a simple neutral interpretation of the scenes. Start to develop a look of your movie in the field rather than at the computer. For example, in winter, you might want the colors in an outdoor scene to look cooler; if you are in the desert, you might want the scene to look warmer.

You can certainly do many of these adjustments in the editing process. But these modifications come at a cost of rendering time. And when you are shooting a lot of shots, the rendering time can add up quickly!

The usual process for setting a custom white balance is to shoot a sheet of white paper or a gray card. The camera evaluates the image and removes the color cast. This is a process videographers have had to do since the introduction of color video cameras.

What if, instead of using a neutral card like gray or white, you used a slightly tinted card? The camera will try to correct or "balance" the color out of the scene. Instead of removing a color cast, you are introducing one for a creative purpose. The idea is to balance off of a tint that is the opposite of what you want in the scene.

For example, to bring warmth to a scene, try white balancing on a light blue sheet of paper. To move the scene towards a cool color, try shooting paper with an orange tint to it. Each time, the camera removes the color tint of the paper by (essentially) adding the opposite color to the scene. You can find papers in artists supply shops or craft stores.

Subtlety is the key here. Unless you are creating a science fiction movie, use papers that are very lightly tinted. In the images seen here, watch the colors of the tree behind the paper.

Here the camera is at a white balance preset (before custom white balance). The paper is slightly blue; notice the color of the tree needles behind the paper.

With the custom white balance set to neutralize the blue paper, the scene takes on a yellowish-golden hue. Note that the blue paper has been corrected to appear close to white; more importantly, notice how the needles have more warmth, more of a golden look to them.

Here, white balance is taken in the other direction with a warmer sheet of paper. The tint of the paper is a very subtle peach-like color.

After setting a custom white balance, the greens are much cooler. It is important to note that neither setting is "wrong"—it is a creative decision on how you control what the camera sees.

6

CREATING VISUAL VARIETY

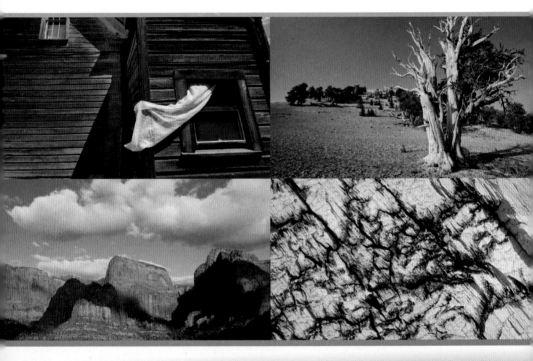

CREATING
VISUAL VARIETY

Still photography is about the single shot. Video is about shooting a variety of moving scenes over time. As you edit video clips, you combine many different shots to create a comprehensive visual, so you need a wide variety of shots to make the editing work.

With video, a sense of movement is also important. Motion can come from moving the camera or it can come from movement in the subject or scene. Every shot does not necessarily need movement—in fact, that can be quite annoying to watch if it is overdone—but you need enough shots to give a feeling of action. This is called creating visual variety.

COVERAGE

The first step in creating visual variety is to get coverage. Coverage in video means going out and making sure you are shooting enough video in length and variety. This requires a very different mindset from shooting still photos. When you are making a photograph, you could put a lot of effort into getting the best picture possible. But then taking the shot itself takes a fraction of a second, most of the time, and you're done.

With video, shooting one scene is rarely enough because you are not going to simply put up a scene on a screen and expect people to continually watch that scene. Viewers expect video to show them a variety of shots that create interest and movement. They want to see both the wide shot and the close shot of a subject, for example. People expect this because this is how television shows or movies are shot.

These shots were made during a parade in Cusco, Peru. Coverage means looking for lots of shots that can work together.

VIDEO COMPOSITION

Composition is how you frame a scene and its visual elements with your camera. Many of the things that you learned about composition with still photography apply to video. A clear, simple composition that a viewer can readily understand is always important. Getting your subject out of the center of the frame so that you gain more life and vitality to the image—or the rule of thirds—is also important. But there are several things that you need to know about composition that makes video different from still photography:

HORIZONTAL: There are no vertical compositions in video. Video is a horizontal medium and is designed that way unless you're creating a special effect or you can mount a television set sideways.

ASPECT RATIO: HD video uses a 16:9 ratio, meaning that it is nearly twice as wide as it is high, unlike the 3:2 ratio common for many D-SLR cameras.

WIDE COMPOSITIONS: Learn to compose over a wide area within your visual frame. Your video will get boring in a hurry if your subject matter is always in the center of the frame and the rest of the image area has little interest.

WATCH THE EDGES: Watch the left and right edges. It is very easy to forget about these edges because they are so far out from the center of the picture in a wide format, but they will be noticed.

MOVEMENT: Composition includes movement. As something moves through your image area, or as you move the camera, the composition will constantly change.

OUTPUT: Think about where your video will be displayed. The experience of watching a movie on a larger screen versus in a small window on the web is quite different. Subtle details are lost on the small screen, and everything is seen on the big screen.

You cannot edit video that you haven't shot. It seems pretty obvious, yet video shooters often start editing, only to discover that they don't have the needed footage (footage is an old term that refers to the length of film or videotape and is still used to refer to an amount of video).

SHOT VARIETY

Shot variety is very important for creating a good video. Shooting one scene is almost never enough if you want an interesting visual. One continuous scene from the same camera angle and perspective bores viewers very quickly.

Once you start editing your own videos, sooner or later you will discover that you don't have a piece of footage that you need to tell the story you envision. Maybe you want a close-up shot of a person; or you need a detail shot from a scene for which you only shot a wide shot; or perhaps you need reaction shots from a crowd to make a better, more balanced edit. You won't know exactly what you need until you sit down to edit, so it is best to cover your bases when you are shooting.

SHOT LENGTH

In addition to variety, it is important that you make each shot long enough. Photographers new to video often make the mistake of creating video clips that are too short.

It is frustrating to begin editing only to find out that a particular clip is not long enough. It is common to need a lot of video to tell a story—in many cases, you will find that much of the footage doesn't work for various reasons—so you need options.

This doesn't mean that you leave the camera running; it means that you record more than just a few seconds of a scene. A good rule of thumb is to be sure that you record at least 10 to 15 seconds of footage for every scene that you shoot. We will talk about this more later in the chapter, but if you are doing any sort of camera movement—such as a pan or zoom—start recording the clip while the camera is perfectly still, and let it run for at least 10 seconds before you move the camera. Then, let the camera record for 10 seconds past the end of the move.

QUICK TIP

The 10-Second Rule

Always remember to begin shooting before the action starts and stop shooting after action the action ends. Use the 10-second rule as a buffer on each side of the clip. The rule is to record at least 10 seconds of any scene before the main action, at least 10 seconds of main action, and 10 seconds after the action stops. You can use a counter in the camera if it has one, count to yourself, or count based on a standard "signal" from your camera, such as a blinking record light.

SHOT TYPES

Adequate coverage for video means getting a variety of shots. We can break those shots down into four types that you can always keep in mind: wide shots, medium shots, close shots/close-ups, and extreme close shots/extreme close-ups. The film and television industries have done this for a long time, so there are certain conventions established for shot variety. (You might run into other terminology, like long shot instead of wide shot, or close shot compared to close up, but the exact words aren't as important as the concepts.)

WIDE SHOT (WS)

The wide shot, as you would probably expect, is a wide view of a scene. It establishes a large setting or environment. A wide shot is sometimes called an establishing shot because it usually sets the stage for your subject and maybe your entire video.

It might seem that this is simply a wide-angle shot, but a wide shot has nothing to do with focal length (although a wide-angle lens could certainly be used). If you are close to your subject and its setting, you might need a wide-angle to get it all in the same shot; however, shooting a wide shot can also be done with a telephoto lens at a distance.

The wide shot refers to how the subject fits in and relates to a setting. A wide shot for a mountain is very different than a wide shot for a ladybug, and a wide shot for a commercial jet would be very different than a wide shot for a paper airplane. A wide shot usually gives context to the subject.

You don't need a lot of wide shots at any given location. This is sometimes a mistake that amateurs make—recording lots of wide shots of beautiful scenery. These shots might look fine as a slideshow or as prints on the wall, but they rarely go together well in an edited video.

QUICK TIP

One thing a lot of video shooters do is set up and capture a wide shot at the beginning of a shoot so that they know that they have covered that particular shot. This is sometimes called a "master" shot.

MEDIUM SHOT (MS)

The medium shot visually comes closer to the subject than the wide shot. Setting and environment are less important than the subject itself. The environment gives context to the subject.

The medium shot is great for creating and highlighting visual relationships. The medium shot gets us close enough that we can see these relationships, whether they are relationships with people or simply a visual relationship between the subject and something else in the composition. That could be anything from a butterfly visiting a flower, to a child playing with a kitten, to the lead cars in a race. The important thing to keep in mind is not how physically close you are to the scene, but how relationships are visually emphasized.

CLOSE SHOT/CLOSE-UP (CS/CU)

The close shot, or close-up, is exactly as it sounds—a close shot of your subject. The subject is large enough in the frame so that the viewer can see details. The environment or setting is not very important, even as a background. This shot concentrates the viewer's attention on details and creates intimacy with the subject.

A close shot is a traditional photographic close-up; however, a close shot is not automatically a close-up. In the case of video, a close shot refers to how close a subject looks in the frame, not how close the camera is to the subject. A close shot of the side of a building could show off details without being a close-up. You could also get physically close to shoot a flower or a bee, yet end up with a medium shot.

EXTREME CLOSE SHOT/CLOSE-UP (ECS/ECU or XCS/XCU)

The extreme close shot crops into the subject to emphasize a detail, rather than show general details of the subject. This shot is often abstract and typically dramatic because it is so tight on the subject. The viewer sees only this highly emphasized detail.

The extreme close-up shot is a very dramatic contrast to other shots. Amateurs often have a hard time with extreme close shots because it requires them to visually get in tight and close on that subject, tighter and closer than they are often comfortable.

An extreme close shot needs other types of shots with it to create context, otherwise it can be confusing for the viewer. An example of an extreme close up would be the close-up of a person's eye. To give context to the extreme close up, you could have a wide shot of a person sitting in the park, a medium shot of that person reading a book while sitting on a park bench, a close shot of the person's face showing intense concentration, and then the extreme close shot of a moving eye.

CUTAWAYS

The cutaway is a unique type of shot that cuts away from the main action and acts as a bridge between the main action or storyline. It can be any type of shot and is a very important coverage shot because it creates more editing options. You might decide, for example, that your medium shot goes on too long. If you simply take a section out of that shot—this is called a jump cut—without doing anything else, there will be a jarring jump within that shot, which is very distracting to an audience. With few exceptions, jump cuts draw attention away from the scene and emphasize the edit.

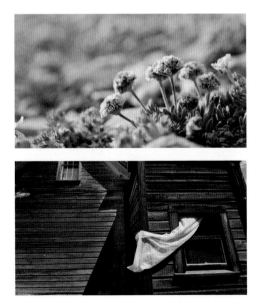

QUICK TIP

Shooting stationary cutaways—shots without movement in them—are very valuable. Later in the editing room, you don't have to match movement from shot to shot.

A clip looks very odd if it is simply chopped up into pieces. The cutaway is used over these cuts in the sequence to get rid of the jump cuts.

Consider you are recording a track event. You shoot the competitors warming up to get ready for the event, getting into their starting position, and taking off at the sound of the gun. At some point during the event, you get a shot of the unbroken finish line tape and coaches reading their stopwatches. All of those shots are cutaways and can be used in editing between the main action shots to show a complete experience of the event.

Cutaways are often close-ups of something in a scene. This could be a close shot within an overall scene, or a small gesture that a person makes. Such cutaways can give additional information about the subject and make your video more interesting. But cutaways are not necessarily all close-ups or medium shots—they can be just about any kind of composition. You may not know when you are shooting a particular shot that it will be used as a cutaway, but if you get in the habit of shooting enough coverage away from the main action, you'll have better success when you go to edit.

REACTION SHOT

A reaction shot is a specific type of shot related to cutaways. It shows a reaction of someone or something to action seen in a previous shot. While not part of the main action, reaction shots can be useful to tell the story and can act as cutaways to help bridge other shots. To continue the track event example, shots of people intensely watching from the stands make good reaction shots.

QUICK TIP

180° Rule

When you are shooting a scene, pay attention to camera placement in terms of the viewer. Draw an imaginary line on the ground that divides your set in half; keep all of the camera positions for that scene on one side of that line. If you cross that line, the viewer may become confused. One example is if you are shooting a football game. If you shoot on one side of the field, the home team will be going from left to right. If you run over and shoot from the other side, the home team will be going in the wrong direction—at least, it will look like it on the video. Obviously, there are situations where crossing the line will not be as confusing, but you should be aware of where you are placing the camera.

CAPTURING MOVEMENT

Movement is the big difference between shooting video and shooting still photography. With still photography, you interpret movement by either freezing action with a fast shutter speed or by showing motion blur with a slow shutter speed. You can never actually show the movement itself. With video, you capture the actual movement of the subject. Now, timing is no longer about an instant of exposure freezing that single key moment, but it is about

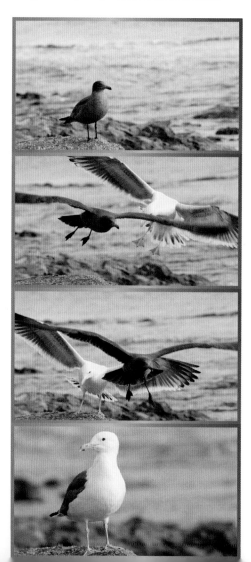

capturing a time period showing the entire movement from start to finish. You have to think about what is going to happen with that movement during that time so you can get the right angle to show off the movement.

SUBJECT MOVEMENT

Movement is not simply about action—it is also about change. In still photography, you might wait for a cloud to move across a landscape to get to a particular spot in your composition. Normally you don't think about that as capturing action or movement. Yet in video, the movement of that shadow across the landscape might be very interesting and sometimes very important. Here are some ways to think about subject movement:

Across the Frame: The subject can move across the frame or composition, from left to right or right to left. Keeping the camera still as the action moves through the frame emphasizes the subject's action, especially when contrasted with a stationary background. This is an interesting way to use action across the

Movement Across the Frame

bottom of a wide shot or through the middle of a medium shot. Start shooting before the action gets into your frame and then let the action go out of frame on the other side; that gives you more options for editing.

Panning with the Subject: Following the subject action with your camera as the subject moves from left to right or right to left is called panning. This can be subject movement, camera movement, or both. While it is possible to pan with a handheld camera, this generally causes some added vertical movement that can be distracting to a viewer. Panning is best done with the camera locked down to a tripod with a fluid head that allows you to pan smoothly. Panning usually looks best with medium and close shots.

Panning with Subjects

Up and Down Action: Some action goes up and down. It can be interesting to see something start low in the frame and go to the top of the frame in a wide shot, as this gives a lot of context to its motion. This is also effective with a subject moving down. Again, keeping the camera still emphasizes the movement.

Up and Down Action

Near and Far Action: You might shoot a subject that is moving from close to you in the foreground to farther away in the background. The subject might not be physically going up or down at all, but will be going up and down visually as it moves through the composition from bottom to top or vice versa.

Tilting with the Subject: Tilting is moving the camera with a subject that is moving up or down. As with panning, you get the best results if you use a fluid head on your tripod. Tilting is also often best with medium and close shots. Sometimes you have to tilt the camera with a subject physically moving from close in the foreground to farther away in the background. Again, the subject might not be literally moving up or down at all, but visually going up and down through the scene.

Gestures: Gestures are a key part of shooting video. This is not simply about people and their hand or face gestures, although they are very important. Gesture here means something broader. Look for something unique in your subject's movement. An animal can have gesture or something unique in its movement. A flag can have gesture in its movement from the wind. A flower that nods with a certain rhythm is gesture, too. If you start looking for this sort of movement—movement that is unique to a subject—you will find a lot of opportunities to add movement to your shots.

Changes in Light: When light is changing, you often have a great opportunity for capturing that movement with video. A blustery day with moving clouds means shadows moving rapidly across a scene. That change in light can be very interesting. At night, moving vehicles, opening and closing doors, or even lights that are turning on and off show changes in light. When shooting changing light patterns, be sure that you're shooting with manual exposure so that the image stays consistent.

Normal Movement: Don't overlook the normal movement of objects. Someone breathing is not all that dramatic—and can't really be defined as a gesture—but it is movement and can add life to a video. This could come in the form of breath on a cold day, where the breath goes out in clouds from a person's mouth. There's also that little hint of movement that can come from the wind gently blowing a branch in a tree. These sorts of movements add richness to the video that tells your viewer that this is not simply a still photo.

QUICK TIP

**Watch Out for Rules—
Try Different Shots!**
Remember that you can only edit what you have. Sometimes it's worth trying some wild and wacky movement of the camera even if you've heard or read that you shouldn't. This goes for more than movement. The more coverage you get of a scene, the more options you will have when editing, so never be afraid to record lots of different shots. If you are shooting with memory cards, it costs you nothing to add extra shots.

CAMERA MOVEMENT

Moving the camera while shooting adds another level of interest to the video. We talked a little about that kind of movement earlier with panning and tilting, but a moving camera can do a lot more. Hollywood filmmakers move the camera quite a lot to add to the intensity and dynamics of a scene. Camera moves can animate a scene that might have very little movement of its own. There are some general things to remember when moving the camera during a shot:

QUICK TIP

Think Twice Before Deleting

Successful video clips are dependent on the editing process. Where a shot is placed in your final sequence gives it context that it might not have if it were a single shot, so you might want to think twice about deleting suspect video clips.

- Consider the composition through the entire shot. If you set up a great initial composition and start recording without considering the whole shot, you will probably end up with a scene that has some good composition and some bad composition in it. Put them together and you get an average composition at best.

- Be careful of too much movement. Movement can cause problems for your viewer and can even create a feeling of motion sickness if it is overdone. Usually this is a result of a camera move that is too intense for the subject, seems uncontrolled or random, or it is constantly changing in direction.

- Pay attention to the direction of your camera movement and use movement carefully. You might not always know how scenes will cut together, so it can be difficult to decide on the direction of camera movement. One technique is to shoot several camera direction options. If you are panning left to right, also shoot a version where you pan right to left.

Panning: One way of creating movement with a static subject is to pan across it. Consider the following when panning the camera:

- Practice the pan several times before you record.

- Know exactly where to begin the pan and where to end it.

- Be careful of the panning speed. Too fast is hard for a viewer to watch; too slow and the viewer gets impatient (plus, a slow pan emphasizes any jerkiness).

- Practice the pan speed before you record.

- If you are tracking a moving object through the scene, lead the subject rather than following. In essence you want to keep the object's framing consistent during the pan.

- Wait a few seconds before you begin panning and stop recording a few seconds after you finished. This will give you more room to edit.

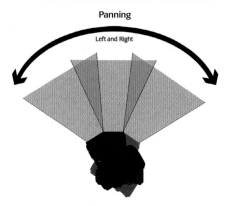

Panning

Left and Right

Tilting: Tilting is a camera movement from top to bottom (or bottom to top) of a scene—in other words, the camera moves up and down. The considerations mentioned for panning also apply to tilting.

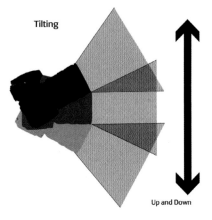

Tilting

Up and Down

QUICK TIP

Repeat shots until you get it. Camera movement can be really tricky. If you pan a shot and then forget where you were going to stop, the end of your pan can look bad. No big deal! Shoot it again!

Zooming: Zooms must be carefully thought out. Many folks overuse zooms, so think about what a zoom will do for your shot. For example, a zoom from a wide shot to a medium or close shot first shows off the setting, and then gives the viewer a more detailed look at the subject. It connects the wide environment with the subject. A zoom from a medium or close shot out to a wide shot focuses the viewer first on the subject, then reveals its setting.

Image Area Changes

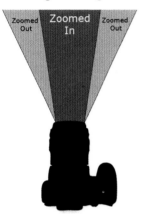

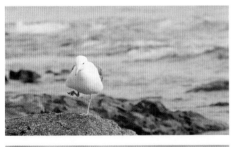

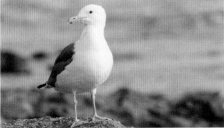

CAUTIONS FOR MOVEMENT

A moving camera can enliven a shot, but the wrong move can make it unwatchable. The difference is often in the speed and smoothness of that movement.

- Always keep speed and smoothness in mind. Unfortunately, we can't give any specific recommendations because the right speed and appropriate smoothness is going to depend on the subject and what you are trying to do with your video.

- Play your clips back and carefully watch the movement. With experience, you will begin to notice questionable movement.

- Practice the camera moves before recording a shot whenever you can. If you get a chance to watch a pro at work, you will see them doing this all the time.

- Check to make sure that the movement is appropriate to the action. Never move a camera just to move it.

- It can be jarring to cut between a zoom in and a zoom out or a tilt up and tilt down or a pan left to a pan right. Consider shooting camera movement in multiple directions to create more flexibility in the editing process.

- Be careful of panning speed. A rapid pan combined with a slow frame rate and capture shutter speed can create stuttering. This is not a digital issue; film cinematographers have always had to deal with this issue. Cinematographers often refer to charts detailing focal length, shutter angles, and shutter speed. Since you have the ability to check playback on the LCD, you don't need charts, so check the LCD playback for any motion artifacts.

WORKING THE SHOTS

In still photography, we talk about working the subject—in other words, continually looking for better compositions and perspectives. Working the subject is helpful when you are shooting video as well. However, working the subject with video also requires a much wider variety of shots for coverage than still photography. This doesn't mean taking a wide shot, medium shot, and close shot just so you can get the best angle possible for a single image; it means shooting a variety of visuals that you can work with in the editing process. You must have that variety or you will not be able to edit your video properly.

It is important to consider the whole range of shots listed here—from wide shots to extreme close shots—as you capture a variety of clips for your video. Simply capturing a variety of shots that only change because the action changes can be very difficult to use when editing. This means paying attention to shooting interesting, thoughtful cutaways. Cutaways add information about the subject, as well as give you more options for a better edit. Make sure you get that range to help you create a better video.

Shoot more than a single framing of a scene. Just because it fits your idea of the perfect composition doesn't mean it will be a beautiful clip. You might end up with one nice shot, but it might not have a place in your edited movie, especially if it is a jump cut. Shooting two different options gives you more flexibility.

As you spend more time editing shots together, you'll see that there is more to shot selection than composition. What precedes and follows a shot can make a dramatic change in how a shot communicates to a viewer. This is why it is so important to get variety.

QUICK TIP

You don't have to shoot in sequence—meaning, you don't have to shoot the opening scene first, or the closing scene last. If you have a particular lens mounted, it is useful to shoot all of the scenes that require that lens. The only time you might shoot in sequence is when you are shooting in natural light and want to show the acutal progression of time.

PROFESSIONAL MOVES

Try physically moving the camera rather than using the automatic zoom feature. Professional filmmakers often truck or dolly the camera, or use a boom. Trucking (or tracking) the camera is a side-to-side movement of the entire camera. This means that if you are holding the camera, you and the camera are moving along with the subject. A dolly is a means of moving the camera from one spot to another within the scene to give some movement and change of perspective. A boom—or pedestal—move describes putting the camera on the end of a long pole and moving the camera up and down.

Professionals use special equipment to be able to do this. You can try some of this yourself for short bits of video that can add some interesting movement. Be careful about doing this sort of movement too long – unless you are pro, such movement tends to look more amateurish than effective. However, if you use a wide-angle focal length and hold your camera steady, you can walk the camera through and around a scene as well as move with the subject. The wide-angle focal length minimizes the bounciness that comes from your movement. Image stabilization can also help keep this movement smoother. You can even try using "wheels" for such movement, such as having someone push you in a wheelchair or pull you in a wagon.

Reverse a Shot

Moving a camera with finesse takes practice, especially a camera move that ends where you want it to and does it gracefully without bumps, jerks, or jiggles. Practice is required. But there is another way to create a smooth camera move ending: Reverse the shot in editing. This means starting the camera move where you want to end, shooting the move in reverse, and flipping the clip in your software.

Even though you might want to end a camera move on a sign, it can be tricky to get a good ending to your move. Start with the sign, for example, then make the move away from it. Reverse the clip when you edit it.

Here is an example. Start with the sign framed up in a static shot, then tilt and zoom into the trees. When you edit the scene, run it in reverse. The viewer will think that is the way you shot it. Make sure you leave enough of the static shot (at the beginning) so that the ending framing lasts long enough for the viewer to take in the composition that will now be at the end.

Obviously, you have to watch for scene movement so that your viewers aren't distracted by water running uphill, birds flying in reverse, cars backing up, or smoke lowering into a fire.

Out Of Focus

Unlike a single image, videos often require titles or credits. While you could just put white text on a black background—it is done all the time—but if it's not done right, it could look like a disclaimer or some sort of epilogue. Instead of using black, or even some synthetic background like a color or gradient, consider using part of a shot to create backgrounds for a title or credits. By shooting some compositions out of focus, the titles and credits now become a part of your video rather than an after thought. It may also get you thinking about how you might title your video and whether you want to add credits or additional textual information to your video.

When shooting video for titles, static shots work best. If there are strong visual elements, keep them to the side of the composition so there is room for text. Play with the focus to get the right amount of detail; you want people to know that the scene is similar to what they have been watching.

An American Pastime

Ultra Wide Angle

You might think that some of the lenses in your bag might be inappropriate for video, but this is not the case. In fact, many videographers using camcorders with non-interchangeable lenses would trade just about anything for a super telephoto or an extreme wide-angle lens.

Ultra-wide-angle lenses give a new look to video and can make a strong statement through an extreme perspective, particularly when close to intriguing foreground objects. Ultra-wide-angle lenses are uncommon in traditional video gear.

Add camera moves to the equation and things start getting interesting. Camera movement accentuates the bending of images at the edges of the frame. The outer distortion that might not be initially visible to the untrained eye quickly becomes evident with a well-executed camera move. While the center of the image moves through normally the surrounding areas move differently. This helps to focus viewers' eyes on the center of the frame.

Tilts and pans of highly geometric objects, like buildings and other artificial structures, while using an ultra wide make for a striking scene.

HOLLYWOOD-STYLE SHOOTING: 10 TECHNIQUES

As you begin shooting more video, you may find yourself paying closer attention to different shooting techniques when you watch a commercial, television show, movie, or even a newscast. There are many techniques that the pros use to make their film stand out. Here are 10 common techniques used by pro video shooters:

SWISH PAN

This is a fast pan—so fast that the shot is just a blur. It is also sometimes called a whip pan. This type of shot is mainly used as a transition element. It is inserted between shots to give the viewer the sense of moving to a new location, among many other uses. It is easy to create this shot—simply pan the camera as fast as you can. To get the best out of the swish pan, plan out the start and stop points carefully. Trying to get the swish pan to stop at exactly the framing you want is extremely difficult. It also helps to have several tonal changes in the scene, because a swish pan of a solid color, like a clear blue sky, won't show much movement.

SNAP ZOOM

A snap zoom is a very fast, blurred action zoom that ends on a specific composition. The speed used to create a snap zoom is similar to a swish pan. If you are zooming in, the snap zoom quickly draws the viewer's attention to the center of the screen. If you are zooming out, the shot emphasizes the overall scene. It is very difficult to perform a snap zoom while simultaneously trying to reframe the shot; that means this technique is best achieved with a camera locked down to a tripod. An interesting way of using a snap zoom is to slow down the actual zoom speed with your video editing software. This accentuates the blurriness of the zoom.

MASTER SHOT

When shooting from a script or plan, a master shot is the main shot that covers all the action in a particular scene. The master is almost always a wide shot. For example, in a scene with two people acting out a scene for a movie, you first shoot the two of them with wide-angle view so that you can see both actors within the entire scene—this is the master. You can then reset the camera position and the lighting and shoot close shots of each performer, cutaways, zooms, pans, etc. Later in the editing process, these shots can be cut in with the master shot to create a well-edited sequence.

Master Shot

Cutaways

SELECTIVE FOCUS

Selective focus is using limited depth of field to define a sub-
ject against an out-of-focus background, foreground, or both.
Hollywood filmmakers often use selective focus for close-ups
to isolate and separate an actor from the surroundings. This is
best done with a telephoto lens set to a wide aperture.

ROLL FOCUS

An interesting use of selective focus is to change that focus within the frame while you are record-
ing. This is called a roll focus, and it can take some practice to master. To achieve this with an HD
video-capable D-SLR, you must use manual focus. First, establish two points of focus—a starting
point and an ending point. Set the focus on your first point, start recording, and roll the focus to
the second point during the recording by turning the focus ring on your lens. Practice the focus
roll slowly until you feel more comfortable. This technique looks great when shot with longer focal
length lenses because the longer lenses magnify the roll focus effect. But longer lenses also inten-
sify other things, including vibrations. To avoid camera shake and other video quality issues, lock
your camera solidly on a sturdy tripod.

SPECIAL LENS EFFECTS

©Lensbaby

The plane of focus is the in-focus part of a scene that is parallel to the camera's sensor. The plane can be at any depth in a scene, depending on where you focus the camera and the aperture setting. But if you tilt the lens separately from the camera, that plane changes, and is no longer parallel to the camera sensor—now it is an angle to the sensor, and creates interesting visual effects. A tilt-shift lens dramatically changes where focus occurs across a scene, and not just from front to back. The Lensbaby, for example, is a special lens that tilts in all directions to place focus in unique areas of your scene while also changing the look of what is in focus.

©Lensbaby

DUTCH TILT OR ANGLE

A Dutch angle is a deliberate and extreme tilting of the camera so that horizons are crooked and verticals are skewed. Hollywood filmmakers use Dutch angles in action, thriller, and horror movies to increase tension, chaos, and drama. The look tends to give an off-balance but dynamic feel to a shot. It is used sparingly for impact, but it must be used strongly so that it looks like a deliberate effect and not a mistake.

LOW ANGLE

One way to immediately gain impact from video is to shoot from a very low angle. Most video—and in fact most photography—is shot from eye-level or slightly lower. Very little is shot from close to the ground, which is why any visual from this angle will grab a viewer's attention. One challenge is that few D-SLRs have the tilting LCDs or viewfinders typical of pro video and film cameras. Still, try it and play back your footage to see if you got the shot. A beanbag or other small support can help you get low and hold your camera steady.

POV

One goal, shared by every filmmaker, is to make the viewer feel like they are part of the action. The use of a point-of-view (POV) shot can help the filmmaker accomplish this goal. A POV shot places the camera at point that shows the perspective of the subject and gives the viewer an interactive experience. Different POVs give the viewer a sense of connection to a character. For example, if the actor is looking directly at the camera, it gives the impression that he is talking to the viewer. This technique is commonly used in documentaries.

Now imagine viewing a scene of a video where you, the viewer, are placed behind the wheel of the car. The camera in this scene is positioned in a way that allows you to imagine you are driving—this is an engaging POV. A realistic POV will shift the viewers' focus around the scene, first isolating a flower or a bird, and perhaps looking up at the clouds.

OTS

An OTS (or over-the-shoulder) shot is used when shooting dialog or action between two people. Pros shoot a master shot of the two going through all of their actions/dialog, then reset the camera and shoot each person in a close up. During editing, they can then cut between the three shots. A close up of one person talking tends to take the person listening out of the scene, but by framing the close up so that you catch a bit of the shoulder of the listener, you bring them back into the context of the scene. Consider shooting a close up and an OTS for the most flexibility when you go to edit.

There are two additional benefits of shooting OTS. On movie sets, many times the close ups will just involve the person talking while the listener is off in their trailer. This makes it more difficult for the person talking,

since they have no one to talk to, and causes two problems. First it take a great actor to talk to thin air and still be convincing. Second, the person speaking needs to look at something so their eyes appear to be looking in the right direction—not to high and not too low. In the film industry, this is called an eyeline. If the actor is looking slightly down in the close up but slightly up in the wide shot, the two shots will look disjointed when they are edited together.

7

RECORDING AUDIO

RECORDING AUDIO

Audio is not something most photographers think about when making images. We might notice the sounds of birds chirping or a plane flying overhead, but as photographers, sound has little to do with taking photos. What we care about is a still image or images that portray a certain subject.

However, with video we have to think about audio. Video is only "half the picture" and is not complete without audio. We have to decide how sound can best be used in our video.

a noisy world

Our world is a noisy place. Sometimes those noises are absolutely wonderful and can help make a video look better. But there are also times when the ambient sound around a subject is distracting or creates a problem. It is important to recognize what is good or bad about the audio in the setting in which you are recording.

If you are recording a person talking to your camera, for example, the camera sees the person just fine, but the microphone picks up more than just that person's voice. While the camera sensor sees only the view through the lens and what the lens is focused on, a microphone is non-discriminatory—it hears sounds from all around it. A shotgun mic, for example, isolates sounds in a narrower angle, but it will still pick up loud sounds behind the subject and/or the camera. All mics pick up additional sounds.

If you are recording someone talking in front of the camera, and a motorcycle starts up down the street, the motorcycle will be recorded along with the person's voice. There isn't a clone brush for audio; while you could clone away the image of a motorcycle in a

photograph, you can't clone away the sound of the motorcycle and still hear the person talking. Or, you might be recording a beautiful nature scene with ducks swimming in a pond as they quack happily. Then a helicopter comes over the pond and adds its sound, which you probably don't want. Situations such as these are frustrating when you are trying to get clean audio—audio that doesn't have a lot of extra sound beyond what you are trying to record.

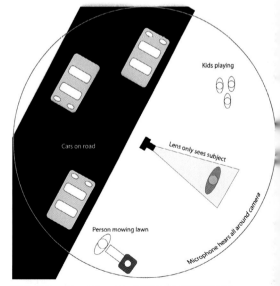

While the camera only sees what is in front of the lens, it hears everything around it.

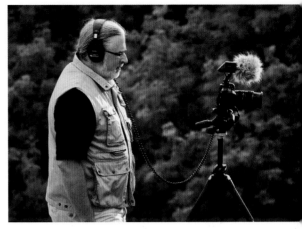

RECORDING TIPS

How do you deal with sounds when you are on a shoot? Here are some ideas:

Pay Attention to Sounds Around You: Over the years you have honed your visual skills, but now is the time to focus on listening. This is not something that you casually do while you are setting up your gear, for example; it is something that requires your full concentration. Sit or stand quietly and let your ears adjust to the sounds around you. Become aware of more than what is in front of your lens. Listen to all the sounds in the area; your microphone will hear that and more.

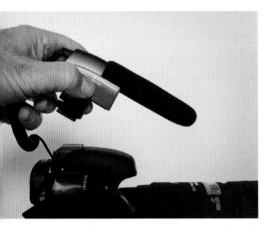

Reposition the Microphone: Built-in microphones cannot be repositioned, but shotgun and lavalier microphones can. Add an extension cord to a shotgun mic and angle it toward your subject so that it is not pointed on axis with the undesirable sounds. With a lavalier mic, try to position it so it is shielded from those sounds, or have the subject turn to a different angle.

Listen for Bad Sounds in the Playback: In this case, headphones are really helpful. Just as you'd never use the LCD on your camera to judge final image quality, using the built-in speaker on the camera is not a substitute for headphones. But if you do have to use the built-in speaker of your camera to judge sound, get your ear close to it; this may still help you to hear if you are picking up a bad sound.

Record During Breaks: If you concentrate on the sound around you, you'll often find that it comes and goes. A good example of this would be somebody starting up that motorcycle. Usually they will either turn it off or drive away, and you can continue recording.

Replace the Audio in Editing: Sometimes that is all you can do if you're in a location with a lot of steady noise. For example, if you are recording Old Faithful in Yellowstone National Park, you are going to get sounds of people because there are always lots of people there. In that case you are going to have to replace the sound with something else.

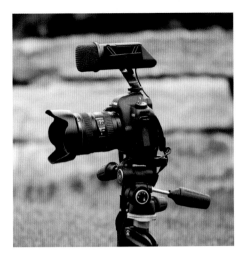

Use the Ambient Sound: If you can't beat 'em, join 'em! Capture some video of the object making the sound and use it as a cutaway in your video. This doesn't always work because sometimes the thing making the sound is totally inappropriate. However if you are photographing a person talking in front of a natural scene and a crow keeps interrupting, you can record an audio clip and a video clip of the crow and insert it during editing so that the viewer knows where the sound is coming from.

Record Sound after the Light is Gone: Not all audio has to be in sync with the video. For example, the noises while standing on a pier at a lake just before dawn will be about the same as they were the night before when it was full of people watching the sunset over the mountains to the west. Record the sounds without the crowd to get clean background audio. Check the playback to make sure that loud sounds aren't overdriving the audio input circuitry.

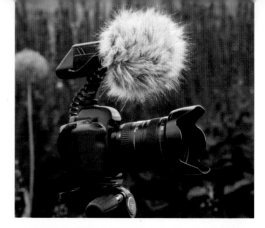

Use a Windscreen: If your mic comes with a windscreen, always use it, even if there is no wind. If the mic didn't come with one, consider purchasing a properly fitting windscreen. This is a small, inexpensive item that can make a big difference in the quality of your audio.

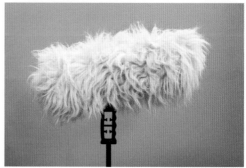

Point the Mic at the Subject: You can't always get close to your subject, which is why a shotgun mic can be very helpful. Regardless of the type of mic you're using, be sure to point it so that its most sensitive area of recording—the pickup area—is aimed at the subject. Likewise, make sure the subject is pointed at the mic.

Microphones do best when close to the subject. This will make a huge difference in audio quality. The closer you can get your microphone to the subject, the better. But beware of placing the mic too close, causing overdrive. This can be one advantage of using a wireless microphone setup because you can really get the microphone close to your subject.

Even if the mic is mounted on the camera, you need to be sure it is pointed at your subject, regardless of the composition.

Handle the Camera Carefully: Be careful how you handle the camera. A mic picks up noise from the camera, especially if it is attached to the camera. Even something hitting the side of the tripod will be recorded.

Wear Noiseless Clothing: A lot of outerwear, from jackets to parkas to rain gear, has a hard outer shell that is very noisy when you move. Doing something as simple as panning your camera can create a rustling sound that is very disruptive to your audio. Soft clothing allows you to move without making noise.

Stand Still: Wearing quiet clothing won't help if you are moving around, jiggling keys in your pocket or whispering to an associate. Stay still when you record audio and remain quiet.

Turn Off the Cell Phone: Don't just put it in vibrate mode—turn it off. While it is common sense that you don't want the ringer going off when recording, most people don't realize when cell towers communicate with cell phones to establish their location, the cell phone will momentarily boost its power. This transmission can be picked up by the mic or other audio circuitry and cause interference in your sound recording.

Moving Cameras Mean Moving Mics: Moving a camera with a mic attached can give weird audio affects. As your camera moves through a scene, the mic will keep changing what it hears. A fast-moving microphone can create artificial wind noise that will ruin your recording. Even a good windscreen won't be able to stop this noise.

Fresh Batteries: If your microphones use batteries, always use a fresh set when you begin recording. When battery voltage drops in some audio equipment, it may still work but the recording quality can quickly diminish.

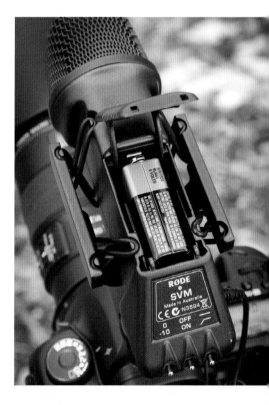

RECORD AMBIENCE

We talked about coverage—getting a variety of shots to cover a scene for editing—in the last chapter (see page 73). Another thing to consider when shooting coverage is to include ambient or wild sound. This means recording the background sounds of a scene. It often helps to point the camera at something unimportant, but also something that will help you identify this clip, such as your camera bag, so that you know this clip is being recorded for its audio. But be sure the microphone is pointed toward the sounds of the environment.

Background audio can be important when editing. You can remove the bad sound track from a good video clip and replace it with the good sound track from your ambient recording. Sometimes it is difficult to get a long string of good natural sound, but having even

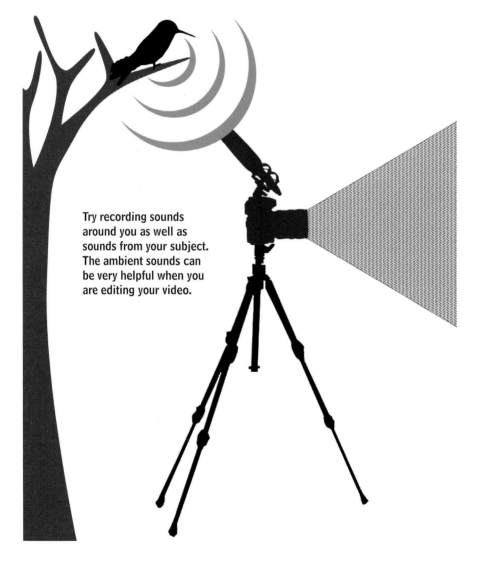

Try recording sounds around you as well as sounds from your subject. The ambient sounds can be very helpful when you are editing your video.

a short recording of good sound can be used here and there with your video. It will give the video a more authentic tone than if you only used music or narration. For example, watch something on the Discovery Channel. Even when the narrator is talking, the ambient noises are present, and give context to the visual.

While the camera is recording, do nothing other than listen. Don't move, talk to a companion, or pack your camera bag; stand there and let your camera record sounds. Record at least one minute of ambient sound. (You quickly discover that this is one of the longest minutes you will ever remember!)

Another use for this sound will be when you are editing two scenes together that don't match perfectly and no matter what you do, the change between the two scenes is a little awkward. Adding a natural sound that bridges the edit will make the two scenes come together much better. In addition, there are times that one scene will have a wildly different sound than the other one. By adding some ambience underneath both of those scenes, they will often work better together with a layer of shared audio.

And finally, you may have recorded something with several different shots. For example, you might have a person talking to the camera in a medium shot and a close shot. They go together very well, except that, in the best close shot, there is a faint sound of gulls overhead. If you had recorded some of the ambient sound of the gulls, you could add this to the second shot, to bridge the sound between the two shots.

QUICK TIP

When recording ambient audio, make sure your clips are long. You never know when you'll need it and ambience can change in a short amount of time.

8

EDITING SOFTWARE AND HARDWARE

EDITING SOFTWARE
AND HARDWARE

Video editing is often a stumbling block for photographers because they assume it is a complicated process. In the next two chapters, we will help you get past the intimidation and get started editing your videos. In this chapter we look at the software and hardware that you will need for editing. In the following chapter, we'll give you some specific tips on the process of editing. We're going to start with software even though hardware is equally important. However, we want you to get an idea of what is possible for editing before getting bogged down in the hardware.

EDITING SOFTWARE

Since most photographers have never used video editing software, they may find it difficult to judge which software is right for them. Video editing software is quite different than standard image processing software such as Photoshop or Lightroom, although you will find certain products have a consistent look to them when they're from the same manufacturer. For example, Adobe Photoshop Elements has a similar interface to Adobe Premiere Elements and Adobe Photoshop has a similar feel to Adobe Premiere, but the programs work very differently. You will have a learning curve when dealing with video editing. This section will give you some ideas as to how to look at the software and how to get started with it.

STANDARD FEATURES

Import Video: You can import video from cameras and camcorders through most video software. If you are shooting to a memory card, you can drag and drop the video files to your hard drive without using video software, but you will usually need the video software to access, view, and edit your video clips. Apple Aperture 3 is a unique image processing program because it allows you to import both video and still images into its catalog where you can then access, view, and organize them, as well as trim video clips and edit them into simple sequences. Adobe Lightroom 3 is similar but does not allow you to trim clips or put them into sequences.

Organize Clips: Separate shots of video are called clips. Video software gives you a way to access, view, and organize these clips, in something usually called a clip bin. While you may follow our recommendations in chapter 6 about making sure you have enough coverage (see page 73), this can result in an overwhelming number of clips in your edit bins. The ability to organize these clips helps you gain control of the footage.

Trim and Edit Clips: You need to be able to trim off the bad parts of your video clips as well as isolate and use good parts. All programs do this, but how they do it varies greatly. Some programs are more intuitive than others.

Place Clips into Sequences: Video is made up of a sequence of clips. Video editing software allows you to select and order the clips for a sequence. Pinnacle Studio and Adobe Premiere Elements include both a traditional timeline and a scene or shot line. Apple Final Cut Express uses only a traditional timeline. Apple iMovie uses a filmstrip that is a simple drag-and-drop for basic edits, but is a bit challenging to use for anything more complicated.

Change Clips in the Timeline: You need to adjust the length of your clips, where they start and end in relation to other clips, move them around, and so forth. This is incorporated into the filmstrip with Apple iMovie in what is called the Precision Editor. Other programs use a combination of timeline and virtual monitors to help you do this, which seems to work well for most photographers.

Preview an Edit: You need to be able to see what your clips look like as you change their length or use parts of them for a sequence. All of these programs have a virtual monitor included to display a video clip, sequence, transition, or a final edit.

Work Non-Destructively: You need to be able to experiment with clips—going from wide shots to medium shots, and so forth—without affecting the original video files.

Edit Video and Audio: Since video has a visual and audio component, you need to be able to work with both during editing. While you can do this with all programs, it is a little awkward in Apple iMovie because you don't initially see separate video and audio tracks. You have to extract the audio to create a separate audio track.

Transitions and Effects: You will need to connect clips using an effect, such as a dissolve, to blend them together. All programs do this to a varying degree. You probably won't need a lot of different effects and transitions for most video editing. However, if you do want to incorporate certain special effects, check the software manufacturer's website to see if they are included in a particular program.

Add Multiple Audio Tracks: While you might have natural sound that you recorded with the video, you may want to add additional sounds and/or music.

Create Titles: Video never looks completely finished without titles at the beginning and end of your edited program. All editing software offers at least basic titling ability, with some offering sophisticated titling capabilities.

Export Video: Once you are done editing your video, you need to get it into a form that can be used elsewhere. This can be a file that will be viewed directly on your computer or a DVD that can be played elsewhere. Video editing programs either have DVD export functions built into them or have a bridge to another program that does this.

BASIC LOW-PRICED SOFTWARE

There are a number of programs on the market designed to make video editing easy for the average photographer. Even at their low price, they offer some sophisticated editing tools. The biggest difference from more expensive software is that they have fewer tools. Many photographers will find that these programs give them more than enough capabilities for working with their video. Such programs include Apple iMovie, Apple Final Cut Express, Pinnacle Studio, and Adobe Premiere Elements.

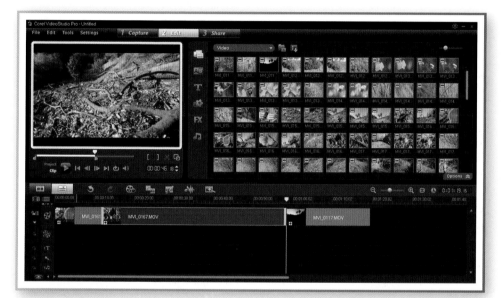

Corel VideoStudio Pro

Adobe Premiere Elements

ADVANCED HIGH-PRICED SOFTWARE

Programs such as Adobe Premiere, Sony Vegas, Avid Media Composer, and Apple Final Cut Pro are extremely full-featured and often used by the pros. This abundance of features results in rather complex software that can be very expensive. While they are well worth the cost for pros who need the extra capabilities, the average photographer's needs will be significantly less. Professional software expands on the typical editing functions:

Import Video: Advanced applications support an expanded list of codecs and offer extensive file transfer functions for pulling footage from tapeless media, allowing for editing of both low and full resolution clips.

Organize Clips: Some of these applications were built to edit long format projects, like feature-length films, which require managing hundreds or even thousands of clips. There are tools for adding descriptive notes to clips, sorting by a myriad of methods, and using metadata.

Trim and Edit Clips: Professional applications offer special trim modes, allowing you to repeatedly play back an edit and trim the edit. They also offer other options for adjusting edits quickly and easily.

View Clips on a Monitor: Advanced applications may make use of additional hardware that allows you to play back your edits on a video monitor.

Preview an Edit: All programs allow you to preview your edits, and if you have a two-monitor setup, some applications allow you to use your second monitor as a full-screen preview monitor to play back your edit.

Adobe Premiere Pro

Apple Final Cut Pro

Advanced Editing: Advanced applications give you access to color correction filters and other plug-ins to help you give your edit a cohesive look.

More Levels of Undo: More advanced software gives you more levels of undo, as well as the ability to keep multiple copies of sequences so that you can try various options quickly.

Edit Video and Audio: Since most advanced applications allow for multiple video and audio tracks, they also include tools to make adjustments to the video (like color correction) and to the audio (like compressors/limiters). With some applications you can even send your audio track to a special audio mixing studio software package, and your video tracks to a special motion effects application.

Create Advanced Titles: Professional applications let you add multiple layers of text, and also overlay graphics created in Photoshop or other applications.

Export Video: While some applications give you plug-and-play options for creating DVDs and uploading to YouTube, the more advanced software gives you more control of the output process. Some software gives you preview windows to see what your video might look like on various devices, like phones or portable gaming systems.

QUICK TIP

Choosing an editing application can be overwhelming. One thing to keep in mind is the more popular applications are typically supported by more learning opportunities. For example, you may find more options for classes at training centers or online for Adobe Premiere or Final Cut Pro than you will for other software.

HARDWARE

Software is only one side of the equation. Having the right hardware can turn the editing process from one of frustration to one of creative opportunity. If you have had success editing RAW image files of 12 MPs or more, you might already have some of the hardware needed for editing video. Remember that although a single HD video frame is at most 2MPs, your editing system will need to process hundreds of thousands of these images. If you have a 10-minute video, the computer will need to handle over 18,000 frames.

There are applications that transform either a Mac or Windows platform into a great editing machine. You will even find some cross-platform applications. However, as new camcorders are introduced using newer codecs, you will have to update these editing applications and operating systems.

THE SYSTEM

When you are considering computer needs, it helps to break the hardware up into a few parts: the central processing unit (CPU), memory (RAM), storage, monitoring, and input/output (I/O).

© Apple Inc.

An iMac has the power needed for video editing.

CPU: Here, faster is better. There are two main specifications for computing chips: their speed in gigahertz (GHz) and the number of "cores."

Generally speaking, a higher number in GHz means a faster processor. For most computer systems, you can just look at processor speed. The second specification is how many cores a CPU has. Think of a core as a small CPU (or a small computer). CPUs have dual cores, quad cores, and eight cores (and probably by the time you finish reading this there will be 16 core chips). More and more applications being produced are multi-core aware and can speed up processing time by sending work to each core. Look for a multi-core processor with a speed of at least 2GHz.

Macs now use the Intel processor that is popular in Windows machines. This is important to know because some new codecs and applications require Intel processors, a trend that will most likely continue in the future.

RAM: While you don't need the kind of RAM that Photoshop requires as far as "scratch memory," you still need to have enough memory to keep things running smoothly—usually this means around 2GB. Be sure to check the recommendations for your computer to see how the memory slots should be populated.

A typical pro choice for video editing is the combination of a Mac Pro computer and Final Cut Pro or Premiere Pro.

© Apple Inc.

Windows-based computers come in a wide-range of capabilities. Most dual-core (or better) processors handle video very well.

© Hewlett-Packard Development Company, LP

Storage: Storage is a critical factor for editing HD video. While still images are large, you generally work on only one at a time. With video, the computer is handling multiple images for each clip. Add in the fact that you are working on several clips at once in an edit, and storage quickly becomes an issue. To give you an idea of how big the files might be, consider that—depending on the editing codec used—one hour of footage might take up 12 to 60GB of storage.

QUICK TIP

Be patient with your computer. It is a lot of work to handle thirty 2MP images per second. Your computer has to work even harder when doing effects like transitions, color correction or adding text overlays. You may find that you have to frequently preprocess or "render" these effects on your timeline for good playback.

The storage also needs to be fast. The disc system needs to be able to serve up the frames of video fast enough (30 or 60 fps) to present your movie. If it can't keep up you'll drop frames and your video will stutter.

One way of speeding up storage is to use hard drives that spin faster. This way they can quickly find and access the data. Look for hard drives that spin at speeds of 5400 and 7200 revolutions per minute (rpm) and more. For video editing, try to keep to 7200 rpm or you'll soon have playback with dropped frames.

A second way of speeding up storage is to combine multiple drives so that they act as one. This is like adding more lanes to a highway, more cars can get where they need to go. This type of high-speed storage is called RAID. Professionals will use RAID systems to achieve this larger data stream, but it can be expensive and complicated to maintain.

Fortunately, hard drive capacity has gone up while prices have come down. The best way to add storage to your setup is to use external drives. Using an external drive versus installing a drive into your computer allows you to quickly and easily add more storage by connecting a cable.

USB is ubiquitous but offers slightly slower data transfer rates than FireWire. You also have to make sure there is nothing on the USB bus that could slow down the transfer speed. FireWire is standard on most Mac computers but needs to be added to some Windows machines.

There are two speeds of FireWire, 400 and 800. If possible try and use a FireWire 800 connection to get better data rates when editing your video. This can help prevent the video from stuttering.

QUICK TIP

Save your work as you edit. Because of the stress that video files put on your computer's system, you may find that it occasionally crashes. If you save your work regularly, this will be less of a bother.

Video Monitoring: In order to edit video, you need to monitor the playback properly. This can be done on the same monitor as the one you edit from, or it can be done on a second monitor.

A graphics or video card installed in the computer drives the computer monitor. You don't need the latest, greatest graphics or video card; leave those to the computer gamers. The graphics cards won't be doing much processing of video, so they don't need huge amounts of memory either. You only need to ensure that the video card is able to drive your computer monitor at a resolution the monitor is capable of displaying. Also, if you want to use two monitors, you'll need to make sure the card can handle two monitors.

Audio Monitoring: While most computers come with audio cards that can handle video/audio editing, the speakers often leave much to be desired. When editing, you should be able to monitor the audio and adjust the mix for proper levels. Hence, external speakers are a must. You can use headphones, but unless that is how your final video will be heard, it won't be the same experience that your audience will hear. You don't need a full surround sound theater system, but you should look for quality speakers that can produce a full spectrum of sounds.

Input/Output (I/O): At the end of your edit you will output your video, so you need to make sure you have the hardware to do that. If your main output is the web, then a broadband Internet connection is all you need.

If you use a tape-based camcorder, you'll need some way to capture, or ingest, the tape. The camcorder will come with either a USB or FireWire connection, so make sure you have the appropriate port available on your computer.

If your camera records to a memory card, you'll want to have a memory card reader that supports SDHC. If you are using the UDMA version of CompactFlash cards, consider using UDMA-enabled readers. While a non-UDMA reader will work, using UDMA readers allow you to use higher transfer speeds.

DVD optical discs are another output option. However, the DVD-Video format—used for movies and typically played in a DVD player attached to your TV set—does not support HD video. You can convert the HD video to standard definition with a widescreen aspect ratio, but you will lose resolution.

Blu-ray is the current optical disc technology that plays HD video. A single layer disc holds about 25GB (compared to 4.9GB of DVD). Some editing applications come with modules that let you create Blu-ray discs. If the editing program you use doesn't create Blu-ray discs, there are third party applications—like Roxio Toast 10 for Mac or Roxio Creator 2010 for Windows—that enable you to author and burn discs. Make sure that your computer has a Blu-ray burner in order to write to the discs. You can buy external Blu-ray disc burners that connect to your computer via USB or FireWire. If you use file-based recording (memory cards), Blu-ray is a good way to archive your footage.

QUICK TIP

You may discover that the HD video captured by your camera does not playback smoothly on your computer. This can be caused by problems with your computer keeping up with the video data stream. You can minimize this problem by closing all programs except your video program and by using fast storage but that might not solve the playback problem. A more successful solution is to convert your clips into a codec that your editing application prefers, although this might not be easy to find out with low-end programs.

EDITING VIDEO

EDITING VIDEO

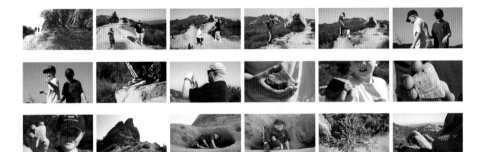

To begin working through this shoot of two boys and their father on a hike in the mountains, it is worth going through all your footage to understand what you have. Most editing software will be able to show you a show series of thumbnails for reference—much like a contact sheet for still photography.

GOOD EDITING MAKES GREAT MOVIES

Video books often have a lot of instruction on how to work with a specific program, and you will certainly need to spend some quality time with your editing software in order to understand it (and may benefit from a specific reference book). But while learning the particular nuances of an editing program is important, what matters most is your ability to envision and create a compelling story out of your raw footage. Being able to put video clips together in an editing program doesn't guarantee that your movie will be good—just as learning how to use a camera doesn't guarantee good photographs. Creativity is key. In this chapter we'll touch on things that you can do to create an engaging video that people will want to watch. Here we'll concentrate on the visual part of the video; in the next chapter, we will deal with editing the audio.

REVIEW THE FOOTAGE

Before you start editing your footage, review it. You need to know what visuals and audio you have before you start editing. With video, you shoot so much footage—or least you should—that it is easy to forget what you did or didn't shoot. Resist the temptation to start building a sequence of scenes; sit down, shut down any distractions, and watch what you have. If possible, review the footage on the same size screen on which you will present your edited piece.

QUICK TIP

Convert the Footage to Edit-Friendly Files

Video files are composed of multiple high-resolution images, and you may find that watching the footage results in stuttering of the video or gaps in the audio because your computer is having trouble keeping up. It helps to convert the footage to a codec that your editing software works well with. For example, with Final Cut Pro you convert the files to Apple's ProRes Quicktime codec. This uses more storage space and the computer might need to do the converting overnight, but that tradeoff usually means better, less frustrating playback.

HOW TO EVALUATE YOUR VIDEO

View your footage with a different set of eyes than the ones you use for still photography. With a still photograph, you are looking for something that gives a complete story in a single image. You might look through all of your photos and pick a few good ones. The single image is key because that's all a viewer can see; with video, however, the single image is never the whole story.

You do need to look for your key shots (again, the emphasis is on shots, not a shot)—those that stand out aesthetically from the rest. This means you have to play them back; just looking at a still image on your computer screen will not help. A great composition that would be perfect for a still photograph will just sit on the screen and not engage the viewer if there is not something happening over time. Now, it is possible to combine a great composition with detail shots that show off movement, but you can't do that every time or your video will feel stilted and predictable.

You obviously want to get rid of clips that are badly out of focus, with terrible exposure, wrong compositions, unflattering gestures, and so forth. But sometimes shots that you would immediately delete as a still photograph should be kept for video purposes. Why? Because sometimes you need a quick (few-second) transition between two shots that don't otherwise fit together. That mediocre shot might work perfectly here because no one will study it as a work of art in itself; it will simply serve as a transition, without ever being the focus of your viewer's attention.

That's why with video you need to look at interrelationships between different clips; some will be obvious (cuts back and forth between two people having a conversation), while others may strike you as a possibility worthy of further exploration. You're always looking for ways to create a greater story by linking video together, rather than just trying to find that single shot that tells it all. A lot of this you will learn as you edit and put videos together; it will become clear what works and doesn't.

Look for groupings of shots—wide, medium, and close—that fit together and work as a unit. This means that if you find a wide shot you really like, see if you have the medium and close shots that might complement it. Those are shots to keep and remember. Look for shots that relate to each other through movement, commonality of subject, and so forth. Always keep the idea of "series" in mind—video is always about connecting a series of shots.

Keep an eye out for lead clips—ones that could start your video. These shots should immediately grab the viewer's attention and set a tone for the rest of the video. Or they could help establish the story—where you are and what you're doing. As you do this, you'll also find some shots that could be used for the ending. Viewers like closure and a well-defined finish. When a video dribbles out to nothing or has an ambiguous ending, people often dislike it even if the rest of the movie was fine. Locate shots that have the most impact or emotion.

And finally, when watching your footage, forget about what it took to get the shot. The footage needs to stand on its own. Your viewer doesn't care if you hiked five miles through deep brush, fighting mosquitoes and heat all along the way to shoot the clip. If it doesn't add anything to the rest of the footage, leave it out.

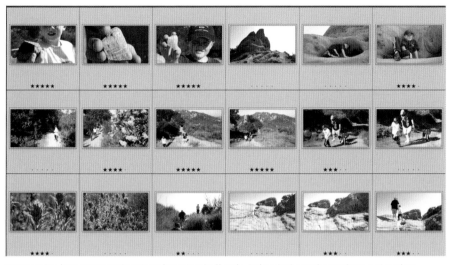

Here you begin to separate the wheat from the chaff. By isolating the best of your shots and setting aside your worst, it's much easier to get a grasp on what you have to work with.

Rate the Clips: Once you've reviewed the footage and picked the best clips, mark or rate them so you can find them easily. Adobe Premiere Elements comes with companion software—cleverly called Organizer—that is useful for viewing, organizing, and rating video files. With Premiere you also get Bridge, a sophisticated browser that accesses your video files and provides a way to rate them. Bridge will play most video file formats. Adobe Lightroom 3 is the first version of Lightroom to allow you to catalog and organize video files (as well as any still photos you might have shot). Lightroom recognizes nearly all video formats from still cameras and gives you tools for organizing and rating those files.

Adobe Premiere Pro or Apple Final Cut Pro organizes clips via bins that act like folders, and the Notes column allows you to add ratings to an individual clip. One rating method is to use asterisks like you would star ratings in Lightroom or Bridge to sort the clips once you have reviewed them. Another method in Final Cut is to use the built-in label system standard in the Mac OS X operating system: Attaching a label to a clip changes the clip icon color for easy identification.

Tips for Reviewing Your Footage:

- Minimize distractions when reviewing your footage before editing. Close other windows on your computer, turn off phones, and close your email. Watch the footage from beginning to end and concentrate on what you have to chose from.

- Don't be afraid to walk away and work on something else. It's a good idea to review the footage once while taking notes, walk away and do something completely different for a while, then come back and watch it again and take more notes. This gives you a fresh perspective and the opportunity to recognize what stands out in your footage.

- Organize your clips before you start reviewing them so that you are looking at groups of similar footage and compare shots. The organization might be as simple as looking at the date and time of the file, or it might be based on subject matter.

sequencing

Now that you've watched all of your footage, it is time to edit the show. The first step in editing is to put the footage into some sort of order. This is done in the timeline section of your video-editing software. A straightforward feature, the timeline allows you to drop your clips into a sequence running chronologically from left to right. This is where you decide whether a clip precedes or follows another, how long each clip runs, and whether it syncs with an audio track or graphic (see the next chapter for more details on audio).

There is no one right way to order your shots; all sorts of ways exist; what works and what doesn't depends entirely on your video's purpose and who your audience is. Think about the goals for your video and why you are putting these scenes together. Answering why will influence how your video clips are put together.

Chronological: Natural chronology can be important. If you are detailing what happened on a trip, then you should follow at least some of the chronology—but careful that you do not arbitrarily put clips together solely because they are in chronological order. Sequencing your movie in this way can create some awkward and boring connections between clips because what you shot chronologically might not go together well in the context of your video. There should be connecting threads between clips, and chronology does not automatically create good connections. The only thing a viewer sees is the final video, so a purely chronological order might not look right because the video has none of the context you had with the subject as you shot it.

This sequence is in a simple chronological order.

Narrative: A story has a beginning, middle, and end. You don't need to have a grandiose Hollywood-style story; all you need is something that has a distinct introductory idea, a definite finish, and a series of events that connect the two. No matter what you shoot, there's often a story involved. Having all of the shots available for your video allows you to develop that story. Pick the clips based on how they fit in the narrative you envision.

Here, the sequence tells a story: an establishing shot of the scene is followed by the journey up the mountain; the story climaxes with the father photographing his sons, and then ends with a shot of them climbing back down.

Visual: The visual qualities of your clips have distinctive elements to them, such as shot type (wide, medium, or close), color, shapes, movement, and so forth. Sometimes you can put clips together based on how they connect with each other visually. You might choose to put together a montage of abstract extreme close ups to give the viewer a sense of wonder, or a sequence of shots of similar color tones to define a moment in time like sunrise.

Impact: Impact is based on the unexpected, and it happens when a video is edited together to affect the viewer on a visceral level. When you order clips in such a way that they create a surprising—yet still interesting—way of exploring your subject, then you gain impact. For example, you could show a wide shot of a track-and-field meet, then immediately switch to an intense close-up of a face deep in concentration as the runner prepares for the event. That is not a usual sort of combination, and can't be used all the time because it would be too jarring, but it would give a lot of impact for this particular sequence.

Conceptual: Many clips link together because of a particular concept. This does not need to be anything elaborate; it can be a simple way of thinking about a group of clips. If you shot video on a trip to a unique city, you might find that you have groups of clips based on traffic, unique architecture, signs, people shopping, and so forth. Those groupings point toward a conceptual order for the video.

Emotional: Is your footage capable of eliciting strong emotions? You may need to arrange scenes to build up a certain emotion, or you may need emotions to come at the right time. You might also sense that you need to give your audience a break. If you are shooting an oil spill and its affects on wildlife, endless shots of waterfowl trying to escape the muck will certainly impact your audience—but they may need some relief before continuing with your story.

Movement: This can be figurative or literal. You might assemble scenes where the action moves in the same direction, such as zooming down a road. Or movement can start with very wide shots and transition into extreme close-ups.

QUICK TIP

Don't worry about achieving a perfect edit between two shots when you first start assembling the scenes. Resist the temptation to keep trimming an edit until it is perfect. Instead, get the whole sequence roughed-in on the timeline to see how the beginning flows into the middle and the middle flows into the end. All that work of perfecting just one edit might be tossed if one of those shots doesn't work when you step back and look at the whole show.

Motion is what binds these clips together. The tension between close-up shots of the boulders and the action of climbing the rock face makes each scene flow into the next.

TRIMMING

Trimming for video is like cropping for still images. You crop to remove distracting elements and boil down your shot to the essence of the composition. With trimming, you eliminate distracting footage at the beginning and end of your clips, so the result is the essence of your scene. Trimming will do more to improve your edit than any type of special effect, so take the time now to learn how to use the different modes of trimming that your editing application provides.

Ripple Trimming: The first type of trimming is called ripple trimming. A ripple trim allows you to lengthen or shorten one clip by pushing the following clips up or down the timeline to compensate. The other clips stay the same length; only their location in the timeline changes. Because the change to one clip ripples down the timeline from the trim point, you must be careful that your video is not thrown out of sync with an audio track.

Slip Trimming: With a slip trim, you don't need to worry about throwing your video and audio out of sync. A slip trim keeps the duration of the clip that you're editing the same, and all neighboring clips remain unaffected. Instead of lengthening or shortening any clips, you are just changing when one clip begins and ends. If it's a 5-second clip taken out of 15 seconds of raw footage, you are just deciding which 5 seconds of footage to include in the timeline— the first 5 seconds, the last 5 seconds, from 2 – 7 seconds, from 4 – 9 seconds, etc.

Slide Trimming: A slide trim is just the opposite of a slip trim, in that it keeps the length of one clip constant—but in the same timeline position—by changing the length of the neighboring clips. Say there are three clips in a sequence: A, B, and C. Initially, each clip is 3 seconds, making the complete sequence 9 seconds long. In a slide trim, you could move, or "slide," clip B to 2 seconds earlier in the timeline. Now clip A is 1 second long, clip B is still 3 seconds long, and clip C is 5 seconds long; the complete sequence is still 9 seconds long. Like slip trimming, slide trimming is useful when you need to keep your video in sync with a separate audio track.

QUICK TIP

When trimming, make sure you playback the edit so that you can see it in context. Some applications have an adjustment in trimming mode that allows you to control how much before and after the edit is played back when trimming. This trimming pre-roll and post-roll setting should be set to a length long enough for you to evaluate the edit as it relates to the shots around it, instead of concentrating on the edit you are trimming.

PACING AND RHYTHM

Pace is the impression of speed or tempo through a series of clips, and is affected by both the action within the shots themselves (e.g., a static subject versus a high-speed car chase) and how quickly different shots are changed (e.g., a series of 15-second clips versus a rapid-fire barrage of 10 clips in 10 seconds). Rhythm is composed of the beats or recurring patterns in the sequence, such as the electric poles passing by the window of a moving train, or a regular pattern of transitions between shots.

A series of long clips of slowly moving subjects, such as grass blowing in the field, gives a slow pace and a gentle rhythm to a video that might be entirely reasonable for a relaxing video about a pretty location. If you had a fast-paced soccer game and used a lot of quick cuts from one action to another, you would retain the fast pace in the video and create a fast-tempo rhythm to the editing, too.

Now on the other hand, a fast-tempo rhythm editing the grass shots together would look awkward and abrupt, plus you would have no idea of what the pace was. Conversely, long clips of that soccer action might start to be very boring because the rhythm of the editing would not accentuate the pace of the action.

Movement in the shot also creates rhythm, and that can come from the camera or the subject. If you are shooting a swimming race, for example, you might start out with slow shots, meaning the action is slow as competitors get ready for the race, along with longer shots (less edits), including swimmers stretching, officials resetting their timers, and coaches pacing. Then you might have a series of quick cuts as the races start; from there the pace might slow down or speed up depending on the story you are telling. It is always important to understand that what happens shot to shot is not an arbitrary change of shot length or transitions.

What is happening in the shots influences pacing and rhythm, too. What you are looking for is a pace (speed) and a rhythm (beat or tempo) that work together through the choice of shots and how quickly the shots are edited together.

QUICK TIP

Serendipity is an editor's friend. When you are editing, think about trying something completely different from what you envisioned. With editing software, nothing is set in stone. It is easy to undo an edit or make a copy of a project and start over in a different direction. Mix up the pacing by cutting in quick shots within a slower sequence. Play around with shot length. Add editing "mistakes" like jump cuts.

TIPS FOR EDITING

Begin by putting your video clips into some relevant order on the timeline. Don't put too much emphasis on this—the first order is simply to get something going. All of this can and will be changed later.

Look for natural edit points. With time, you'll see how some footage will help you see where to cut. A knock on a door, a loon call, or other audio or sonic clues might suggest a good edit point. When a camera move comes to smooth stop, it might signal a good time to start a dissolve. Someone leaving or entering the frame, or a quick glance to something off screen by your subject leads naturally to the viewer wondering what they are looking at and a good reason to cut to another shot.

Any type of back-and-forth dialog (if you have the footage with multiple takes or multiple cameras) will lead to natural edit points. While you can show a person talking and then not talking, the listener's reaction is also important.

Keep your video moving. Let your shots speak for themselves, but pay attention to their duration and keep the pace. For example, camera moves don't have to come to a complete stop; try cutting in and out of camera moves.

Make sure your edits keep the story going. It can be a delicate balance, but you don't want the viewer waiting for a shot to change; better to have them just on the edge of wanting to see the scene a little bit longer.

Pay attention to the direction of movement. A sequence of a few scenes where the camera is zooming or dollying can be effective, but more than a few can give the viewer seasickness. Cutting between a zoom in and a zoom out can be quite jarring—you might want to cut to a static shot (no camera movement) in between or let the zoom in come to a complete rest before the cut. Cutting a left to right pan into a right to left pan can distract the viewer, too.

Look for some sort of rhythm to your clips. You may need to play your timeline multiple times in order to get a feel for this. If you find your computer cannot play the timeline without having problems with audio or video, try rendering your timeline (see page 130), which should take care of that.

TRANSITIONS

Transitions are used in editing to connect clips within a sequence, and range from simple to elaborate. Transitions are important, but you need to use them cautiously and deliberately. We have all seen videos that overuse transition effects (including those wacky late-night advertisements from local merchants that seem to believe that the number of transition effects used has a direct relationship to sales). When these effects are overused, they take the attention away from the movie and you lose your audience.

Cuts and dissolves are traditional transitions, and are a standard choice. If you watch any current movie—low budget or even the biggest Hollywood blockbuster—you'll see that most transitions are cuts with a few dissolves in special circumstances. New transitions are invented every day, and you will learn to understand which work and which don't. Think about transitions as a means to put your scenes in order to tell a story, not a way to spice up a boring video.

Cuts: A cut is as basic as it gets. The first shot ends with its last frame, and the second shot begins with its first frame, with nothing in between. This is a clean, simple way of transitioning from shot to shot, and it is the standard way that most film and video has always been edited. We are so used to seeing cuts that we don't think about them unless the cut is too obvious—something called a jump cut. A jump cut is when one clip ends with an image that is very similar, but not identical, to the beginning

of the second clip, so that the video appears to "jump" across the cut. A famous example is found in The Graduate, where one scene ends with Dustin Hoffman pulling himself out of a pool and onto a raft, and the next scene seamlessly jumps to him leaping into bed next to Anne Bancroft.

Dissolves: A dissolve transition blends the end of one clip into the beginning of the next clip. It creates a certain mood that cuts do not. People are accustomed to seeing dissolves merge multiple images together in a fluid way. A dissolve can happen in a fraction of a second or over several seconds—the speed depends on the clips you've shot, the mood you want to create, the rhythm of the movie, the music used, and so forth.

A good starting place for dissolve duration is 0.5 – 1.0 seconds; in video terms this would be 15 or 30 frames (if the clip was shot at the 29.97 frame rate). You may find that you prefer

a certain dissolve speed. A faster dissolve makes the pace quicker, while a slower dissolve is gentler, and slows the pace. Choose a dissolve speed that is appropriate to your subject. If the pace feels too slow or too fast, it may be the dissolve speed.

There are a few caveats with dissolve transitions. First, be careful about using slow dissolves throughout your piece. One dissolve after another—particularly long dissolves connecting shots of similar duration—sets a hypnotic rhythm that can lull your audience into boredom. While this works well for the opening sequence of Citizen Kane (the slow, repeated dissolves as the camera approaches Xanadu sets the ethereal tone leading up to the haunting intonation, "Rosebud…"), most subjects will be strained by such a dramatic technique.

Another issue with dissolves deals with the movie's final output. Dissolves can add a lot of compression artifacts if your movie will be compressed significantly. If you want to see this in operation, look at any DVD movie that has a dissolve in it and pause during the transition. The reason is pretty simple: If you have a 30-frame dissolve between two shots, then every pixel is changing in each of those frames. Compression doesn't translate well when every pixel changes value; a compressed video file looks much better when many of the pixels stay the same. Granted, every pixel changes with a cut as well, but it happens over only one frame, and too abruptly for most people to notice the compression artifacts. This doesn't mean you can't use dissolves; just be aware that you might see artifacts when you do, depending on the compression.

Finally, watch out for unintended superimpositions. Because the outgoing and incoming scenes overlap and appear on the screen at the same time, you could have disturbing juxtapositions. A car might seem to run into a building, or a strong color might turn a person's face temporarily green. While you can use this to your advantage to create something unexpected, it might also be cause for an unexpected reaction from your audience.

Trendy Transitions: These types of transition depend on your editing software. They pop up like the flavor of the month in an ice cream shop. For a while, people were using page turns where the video curled like pages in a book. Another fad was the use of simple flips where one scene would rotate vertically or horizontally and the incoming scene would appear on the flip side of the first scene. Be careful using these, as they are gimmicky and can detract from an otherwise serious subject; however, if you're showing a blooper reel of funny jokes and slip-ups, it might fit the mood perfectly.

Morphs: Morphing from one scene to another was popularized in Michael Jackson's music video for Black or White to fluidly transform one person's face into another. It became so popular that it soon became a cliché, much like the page turn. Morphs have seen a resurgence, but they are usually executed in a more subtle way.

Blurs: In this transition, one scene ends by gradually applying a Gaussian blur until the scene is a total mush, then switches to an equally blurred second scene in which the Gaussian blur is gradually removed until the image is sharp again. They take a bit of rendering time, but blur transitions are often less blatant and can help avoid an awkward juxtaposition of elements between two scenes—something that can happen in the middle of a dissolve.

Flash Frames: A flash frame is a couple of frames of almost pure white inserted at the edit point. Flash frames are used in rapid fire editing. A flash frame is a very jarring edit; use it sparingly or not at all.

Fades: A common and dramatic transition often used in slow-paced edits is a fade to black. The outgoing shot dissolves all the way to black, and the incoming shot begins at black and fades in. The amount of time the screen is black between the two shots can be varied for dramatic effect. You can also use white instead of black for a brighter, more positive feel.

Audio transitions: Audio doesn't have to cut when the video does. While video editing applications default to cutting the video and audio together, editing them separately gives you opportunities to improve your edits. You can soften abrupt edits by cutting to the next video scene first, but waiting a few frames or even a few seconds to cut the audio. This is called a split edit because the video and audio cuts don't line up. Also, just because the video uses a cut transition doesn't mean you can't use an audio dissolve or fade transition. The transition rate doesn't have to be long; an eight-, six-, or even four-frame transition can work.

aDDING STILL PHOTOS

As a photographer, you will probably shoot still photos along with video. Still images work with video as long as they are incorporated carefully into the edit. They can be a good way of adding more visuals to your video, to give it more depth and texture.

Resize Images: It is a good idea to resize still photos, specifically if you use them for video. Why resize? The biggest reason is that most video-editing applications don't do a good job of resizing stills. Video-editing applications are designed to process multiple frames in rapid succession; they don't have time for high-quality pixel interpolation that would normally occur in a photo-editing application like Photoshop. When video-editing applications scale images, they usually throw pixels away without bothering to recreate the image. For better still-image quality in a video, resize your images to the same resolution as your video (1920 x 1080 or 1280 x 720). However, if you are going to add motion to your still images, like a zoom into the image, resize them accordingly (see "Motion with Still Images" on the next page).

Another reason for resizing your images is to reduce memory use when handling the image. A video-editing application handles frames that are HD resolution, and the software code is optimized for that size. When you start importing frames that are much larger, the computer's memory can fill up quickly, processing can slow down, and the computer might crash. Ease your computer's workload by resizing your images before you import. In terms of final file size that you export from your image editor, video editing applications work with a set number of pixels (e.g. 1920 x 1080) so pay attention to pixel dimensions (resolution), not pixel density (ppi or pixels-per-inch).

File Format: Most editing applications can handle TIFF and JPEG files—and some even handle PSDs—but stick with TIFF files. If you really need the space, high-quality low-compression JPEGs can work, but TIFF files avoid artifacts that can happen with JPEG compression. Most HD video is a variant of sRGB, so you don't need to use another color space.

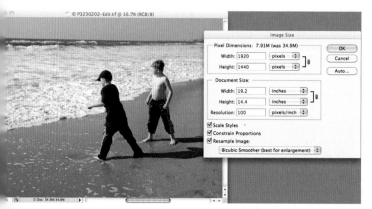

Still photos have far more resolution than video, and should be resized. If your video resolution is 1080, then a width of 1920 pixels is appropriate; if you're working with 720p video, resize your stills to a width of 1280 pixels. Photos should also be cropped to match your video's aspect ratio—usually 16:9.

Determine Clip Length: Video-editing programs import still photos as clips with a standard length of time—commonly 5 seconds. You can change this default in the Preferences part of the program, but 5 seconds is a good starting place when determining how long you want a still photo to be on-screen. Make the still-image clip longer or shorter by dragging the ends of it in the timeline. Be careful about using long clips of a still photo. Your audience expects video to have forward movement, and if a single image lasts too long, the forward movement grinds to a halt. Things that might influence the length of time your still photo is on-screen include:

Music Tempo: Quick photo clips look better with fast music, while longer clips are better with slow music.

Image Style: Simple images with straightforward subjects that are clearly understood should only be up for a few seconds. Detailed images that require a little study can be held longer.

Video Pace: Similar to music tempo, fast-paced films are better with short photo clips, and slow-paced films can handle longer clips.

Motion: If you are adding motion to the photo clip, the duration of the image will depend on the speed of movement (see below).

Transition: A transition takes time to happen. If the image is up for 5 seconds and you want to use a 30-frame dissolve (1 second at 29.97 frame rate) to begin and end the shot, then the scene will be seven seconds long.

Motion with Still Images: Another way to use still photos is to move the video frame around the still photo. This is commonly called "The Ken Burns Effect," because Ken Burns popularized this technique in his documentary projects; but filmmakers have been using it for ages. The photos themselves don't move; the framing changes to create the appearance that the image is moving across the frame, up and down, or zooming in and out. This gives still photos some energy and allows them to be held on the screen longer. It can also help them merge with the motion of the rest of the video.

The Ken Burns Effect uses the appearance of a moving camera through a large image file. In this example, the clip will begin showing the full scene (cropped to a 16:9 aspect ratio), and then gradually pan down and to the right while zooming in on the deer. This can be a short clip, with a rapid pan and zoom, or a longer clip with much more gradual movement.

When Burns first started using this technique, he used a film camera to make these moves across a print; but now this is done in software. Most video software allows you to set two camera positions, or keyframes: one at the beginning and one at the end of the photo clip. The software then animates movement between them. Set the first position tightly framed on an element within an image—for example, deer in a meadow—and set the second position on the entire photograph (see the photo above). The software creates the movement between the two points so that it looks like the frame has zoomed out. To use this effect, you will need images that are sized larger than HD resolution.

VISUAL ADJUSTMENTS

Just as you would process still images in an editing program like Photoshop to adjust brightness, contrast, or color, so should you think about adjusting your video clips. Of course, it is always best to shoot your video correctly from the start, because adjusting the video reduces the file quality; and making visual adjustments to video is neither as easy nor as fast as using Photoshop or Lightroom. But it is important to know what possibilities post processing can offer. You don't make these changes simply to correct mistakes; sometimes you just need to make a couple clips fit together better. In fact, many people like to use the term "color grading" (or "simply grading"), because color correction implies that you are trying to correct a mistake.

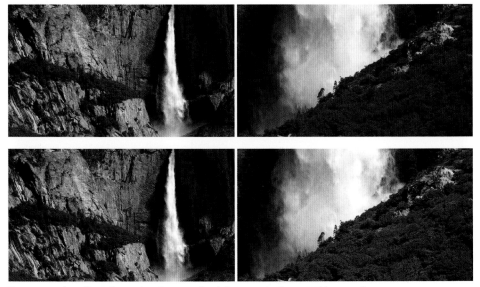

You may need to adjust clips so they flow seamlessly from one to the next. This second shot needed its brightness reduced in order to match the level of the first shot.

Adjusting a clip can have a dramatic effect on the mood it communicates. This first shot is bright and cheerful; the second shot is more ominous and foreboding.

There may be times that you want to make part of your video darker, with a cold cast to it, simply for the mood. Each clip would then have to be adjusted appropriately. Or maybe you want to create a happy mood where everything is bright and sunny looking. Color grading can be used for effect, looks, and more.

You may also need to adjust individual scenes so they fit together better within a sequence. Ensuring that your scenes flow seamlessly between one another, and are internally consistent, is called continuity. If you have a series of clips with one brightness level and then all of a sudden a new clip appears with a totally different brightness, that new clip will look out of place. This can be true even if the new clip is properly exposed. So you will need to take that problem clip and make some adjustments so that it fits the visual look of the sequence.

The decision to go through the color-grading process is yours, but it remains a powerful tool to tell your story and create the feeling you want. Watch any television show or commercial and you will see grading. In fact you might be appalled at how flat and lifeless the original footage looked. Like processing a RAW file, video may need processing to create the response you want from your audience.

One popular image-treatment look is vignetting, which can help your viewers pay attention to the center parts of your scene by darkening the outer edges. Some editing applications have preset effects for this; others require you to layer a vignette onto of your footage. Usually only a light touch is needed. You don't want viewers to notice the effect, but you do want them to experience it.

In general, when it comes to making visual adjustments, try not to get carried away. Processing thirty 1–2MP images per second of video means the computer will have a lot of work to do, and it can be frustrating to slow down your work flow that much. Just familiarize yourself with what adjustment options your particular video-software offers, so you know what tools are available if you really need them.

Rendering and Output

As you color grade scenes and add transitions between clips, you'll discover the painful reality of editing digital video files: rendering. Rendering is the process of creating new video frames based on what you originally shot, such as when you create a transition between shots. For example, to insert a fade-to-black transition, the computer must recreate a series of new frames with gradually decreasing brightness levels—rather like batch processing a series of still images in Photoshop. Sometimes you will add effects to your video that the computer can render in real time while it is playing the video in your timeline; other times the math is too complex and the computer needs to calculate the new frames and write them to disk before it can play back the sequence. If you have ever used a complex filter in Photoshop that doesn't immediately show its effects when you click okay, then you have experienced rendering.

Because rendering is time-intensive, it can slow down the editing process. Consider first assembling the entire sequence and playing it back without any effects so that you judge pace, rhythm, etc. Then apply transitions and other effects, and let the computer render while you take a break. Even though rendering takes time, it really is your friend—it is the only way you can evaluate your edits in playback without dropping frames.

QUICK TIP

If you are on a tight deadline, try a test render to see how long any necessary effects will take. It might take several minutes depending on the effect. That might be fine for one shot, but effects with several shots can really add up. Rendering may also be required when you create the final output, so test the output rendering time to avoid any surprises.

Rendering : 7.93%

Progress

Rendering 1 of 6 Video Previews

Rendering frame 113 of 1434

Estimated Time Left: 00:10:25

▶ Render Details

Cancel

Be careful of rendering times—applications will attempt to estimate time to a finished render, but it is just a guess.

EDITING FOR OUTPUT

During the editing process, keep in mind how your audience will see the finished piece. Take the time to watch the final video exactly how your audience will see it displayed, whether that is on a large, home theater-type screen or a small, web-based video application.

Consider the Final Use: The viewing experience will determine how you cut the video. Large screens show more detail and subtlety, which the audience will pick up on, like whether

a glass is filled with ice in one shot and sud-
denly empty in the next. That same scene
viewed on the web may not allow the viewer to
notice the glass at all.

Check the Aspect Ratio: Make sure that your
video's aspect ratio is correct. If you started
out in HD—natively a 16:9 aspect ratio—only
to realize that the screen on which you will
display your final product is 4:3, you might
have to crop the movie down to the center por-
tion of the scenes, and all of your painstaking
time spent crafting the correct composition is
lost. Another option would be to letterbox your
video into the 4:3 aspect ratio. Letterboxing
means that the full area of your image—all the
way to the left and right edges—will be dis-
played, but the top and bottom of the screen,
where there is no image, will be black. (The
final shape is similar to the slot in a door where
the post office delivers your mail; hence the
name letterbox.) This is similar to printing pan-
orama image onto square photo paper.

Check Effects: Make sure that any effects,
treatments, graphics, typefaces, or transitions
don't put too much strain on the compression
system you use for final delivery. A highly satu-
rated, thin serif font with a delicate outline and
drop shadow might look good during the edit,
but could turn to mush when compressed.

Check Font Size: Tailor any font size to the
intended display size. A small web window
makes it difficult for viewers to read any small
type that you use, and a large screen won't
need large font to be readable.

Check Levels: Always watch your video and
audio levels. Unless it is for a specific effect,
make sure that highlights are not clipped and
shadows are not crushed so you're not losing
detail. Check the audio playback to ensure that
levels are consistent and not overdriving the
speakers. Audio distortion can be even more
distracting than video problems.

QUICK TIP

Editing for a 16:9 aspect ratio can fall apart
when delivering a 4:3 (non-letterboxed) movie.
Since a significant portion of the left and
right edges of the scenes will be cropped off
the movie, consider duplicating your original
sequence and specifically creating a 4:3 version.
Then you can reposition footage so that any
important elements on one edge of the screen
are brought to the center. Some applications
offer guides or overlays to show you the plac-
ing of the crop. Or, you can create a graphic in
Photoshop as a temporary overlay.

EDITING AUDIO

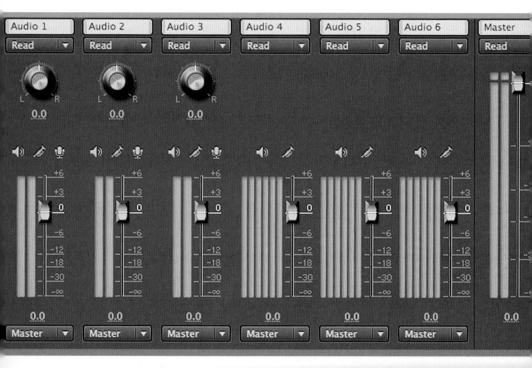

EDITING AUDIO

Audio is often taken for granted, but it has a big effect on the quality of your video. The visual part of video generally gets the most attention from a still photographer, but the audio and how it is edited is vital. Good audio makes any video look better, and bad audio makes even the best video look bad.

GeTTinG STaRTeD

Most audio comes in with your video files. You will probably import, organize, and review the audio along with your video. As you start going through your video, keep notes of the good and bad audio that can be used in editing. Also, be sure to note which video clips have special audio on them, whether that is ambient sound, narration, or people being interviewed. You may want to add music, sound effects, or narration later to your video. In general, it works well to import those elements as you need them.

SYNCING AUDIO

If your camera doesn't record the quality audio that you require, you may end up recording audio on a separate device, which means that you'll need to match up this audio to the video. This is called syncing, and is necessary so that specific audio—such as a person's exact words—match up with the person's actual lip movement on screen. The method of syncing varies with the editing software. There are three ways of syncing audio:

1 **Visual:** With this method, find an action in the video that has a sound associated with it, then find that matching sound in the audio recording and line up the two. This is the method that has been used for years in movie production. It is the reason for the slate held in front of the camera lens. The wooden stick (sometimes called a clapper for

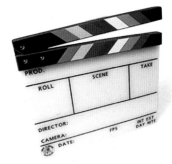

the sound it makes) attached to the top of the slate is slapped down before every take. The sound of the wooden clapper on the audio track is used to match up the video of the slate clap.

2 **Aural:** If you are able to record audio on the camera as reference, you can line up the two tracks by laying them out in a sequence and listening. One track will be offset in time from the other. You then move or "slide" one of the tracks and listen again. Repeat this process until the two tracks are in sync.

3 **3rd Party Software:** This method is similar to aural syncing in that it requires you to record a reference track in the camera. But instead of repeatedly adjusting the sync while listening, the software compares the waveforms (similar to a histogram but displaying audio) and adjusts the sync. The most popular software is PluralEyes (www.singularsoftware.com). PluralEyes is a plug-in for Final Cut Pro, Premiere, and Vegas, and was specifically designed for D-SLR video because of the audio quality limitations in many cameras. It automatically lines up the audio tracks.

A waveform is like a histogram for audio files; it represents the high and low points of an audio clip.

Syncing audio can be challenging, but with a little practice, you will be able to do it. Make sure that as you slip the track and inch up to perfect sync, go beyond that spot and listen to the sync again so that you know the final point is right. Also, check the end of the clip to make sure the sync doesn't drift because of a problem with the audio recorder. Listen to and watch the end of the clip to make sure that the audio recording doesn't end too early.

QUICK TIP

Analog vs. Digital

In the days of analog audio, the numbering scale on audio meters went beyond 0. (And we're not talking Spinal Tap "it goes to 11.") The 0 point on the scale was what you aimed for; any levels that went a bit above zero didn't get clipped or distorted because there was always some buffer area called "headroom." In digital audio, the 0 value is the maximum level—anything above that creates quality issues. Aim for values in the ⁻18dB to ⁻10dB range.

QUICK TIP

Headroom

Headroom is the term used to describe the "safe" decibel area beyond your standard audio levels. If your audio clip level is at -20dB, then you have 20dB of headroom before you get to 0, which is the top of the digital audio scale. Any audio clips that go above 0 will most likely be distorted.

AUDIO LEVELS

Pay attention to your audio—it's that simple. Most video editing software includes good audio controls. Some video software is oriented toward audio, like Sony Vegas, and Adobe Premiere Pro and Final Cut Studio come with separate audio mixing applications. In general, video-editing software allows you to increase or decrease audio volume while editing audio in separate audio tracks.

While having access to multiple tracks is great for building up interesting sound tracks, you have to be careful about building up audio levels, too. Levels are the numerical values that express the volume of an audio clip. Simply adding more sound without reducing some audio levels can bring the audio track over acceptable levels, creating distortion and other problems.

To measure digital audio tracks, you need an audio meter. This will help you evaluate any potential audio issues. Many editing applications include an audio meter to look at in order to set levels. But like a histogram on your camera, if you don't know how to read it you can't really use it. An audio meter measures the audio level in real time as the audio is played back. It is a pretty good representation of how loud or quiet the audio track is.

The scale on the meter is measured in decibels (dB), but it is not a linear scale. This means that the effect of a level change at the bottom of the meter (the quiet section) is not the same as a change at the top of the scale. The scale goes from infinity (∞) at the bottom—pure silence—to 0 at the top. Anything above 0 usually has quality issues. The portion of the scale to pay attention to is between -20dB and -6dB; this is a general guideline for where audio levels should be.

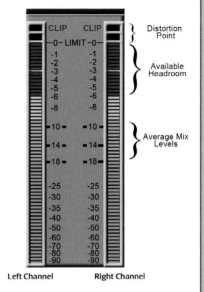

Optimum Mix Levels for Mastering

Left Channel Right Channel

Audio can be a difficult thing to read because it is always changing. Plus, if you have a track with a lot of different audio levels, those changes can be dramatic. One technique for evaluating audio is to look for audio "peaks." Peaks are the highest point of an audio clip. Many audio meters will temporarily leave a small mark at the highest audio peak within the last second or two of audio. Pay attention to these peaks; they are important for editing.

Where should these peaks be? It depends on the medium to which you are outputting the movie. In general, try to keep peaks no lower than -18dB and no higher than -10dB. That gives about 10dB of headroom, just in case. Unfortunately, many output destinations don't have any kind of standards. One quick listen to YouTube shows lots of different audio levels. On the web, for instance, audio levels become a case of the louder the better, so you might boost your mix to -6dB.

HANDLING AUDIO CHALLENGES

There are inherent challenges in editing audio in a timeline. Here are some of those challenges and possible solutions:

SOUND STARTS ABRUPTLY

An abrupt change in the level of sound can be jarring to your audience and make your edit too obvious. This is fairly common at the beginning of a video or between distinct clip segments.

In this waveform representation of an audio clip, you can see that the beginning of the clip is quiet and the end of the clip is loud.

Solution 1: Fade in the audio. Fade ins take the audio clip from silent to full volume—the volume you've chosen—over a short period of time. In many programs, this is accomplished by turning the audio down to zero at the very beginning of the track and creating a control point a little further into the track. The audio increases in volume from zero at the start to your chosen volume level at the control point. Some programs give you automated fade in transitions that are easily dropped onto the front of a clip.

You can always move an audio track around while editing to make it better fit the video. This is called slipping a sound track.

Solution 2: Move the sound track. If the video doesn't have to specifically be in sync with the audio, you can move or "slip" the audio track so that the problem area of the audio track isn't part of the edit. For example, if you are shooting an early morning street scene and the beginning or your shot contains a cell phone ringing that should have been turned off, you could slip the audio past the ringing.

SOUND ENDS ABRUPTLY

The audio cuts out at the edit. This is also fairly common at the end of your video program or at the end of a clip. That abrupt end of sound is jarring and sounds sloppy.

In this situation, the audio cut is just as dramatic going from loud to quiet. You might be cutting from a roaring waterfall to a raindrop gently hitting a leaf. But if it is not what you want you'll need to address it with an audio fade or cross dissolve.

Solution 1: Fade out that sound. A fade out is the reverse of a fade in. It takes the audio from its normal, maximum level down to nothing over a short period of time. In many programs, this is done by going to the audio track, creating a control point close to the end of the clip and turning the audio down to zero at the end of the clip—the audio goes from normal at the control point to zero at the end. Some programs also give you automated fade out audio transitions that are easily dropped onto the end of the clip.

Solution 2: Move the sound track. As long as the video doesn't have to specifically be in sync with the audio, you can slide the audio track so that the problem area isn't near the end of the clip.

SOUND ABRUPTLY CHANGES BETWEEN CLIPS

This is pretty common; audio is rarely recorded continuously from clip to clip, and the sound inevitably changes. When the audio does change abruptly between clips, those bad edits stand out.

Audio edit problems aren't always about a difference in levels. The sounds at a baseball park might have the same level as the sound at a music festival. Even though the levels are the same, the sound is completely different.

Solution 1: Fade out the sound from the first clip and fade in the sound from the next clip.

The audio transition doesn't have to match the video transition. In many cases, while the video cuts, you might want to have a smoother transition for the audio. In the edit shown here, the video is cut while the audio fades out to silence and then fades back in.

Solution 2: Use audio dissolves even with video cuts. Most programs allow you to apply a dissolve to just the audio track. This allows you to blend the audio from the two clips just where they come together. This is also a good reason why you should always record video both before and after the times that you actually need it. That allows you to have things like extra audio for an audio dissolve. Audio dissolves are also called crossfades.

The audio edit doesn't have to happen when the video edit happens. In this case the audio precedes the video edit by several frames. This can be done to smooth out a rough transition or you can use it to emphasize a sound before it is shown on the screen.

Solution 3: Use a split audio edit. A split audio edit means that the audio edit does not line up with the video edit. Split edits work best with applications that allow you to put your audio on separate tracks, however this is not available with all video programs. For example, the video might be edited at the 20-second mark in the timeline, but the audio edit is at the 19 or 21 second mark. To successfully use a split audio edit, you must think about your video and audio separately.

By adding another audio track, you can build up a sound track made up of the sync sound and an additional sound. When the transition happens, not all of the audio is changing, so the additional track helps mask the cut.

Solution 4: Cover the edit with extra audio. This requires a video-editing program that offers multiple track audio and editing. We mentioned recording ambient sound while on location on page 100, and here is where it is commonly used. Suppose you recorded some sounds of birds. Put this audio in a short clip that covers the edit by starting before and ending after that edit. The bird sounds will start before and end after the edit, bridging the edit and making it appear as though you shot continuously. This makes the visuals look like they belong together.

SHORT UNWANTED SOUNDS

You might have a recording track where there is a brief sound that you want to get rid of. Let's say you are recording a croaking frog on a rock and you accidentally drop your lens cap. That quick noise ruins a great ambient sound recording of the frog. You can treat it like you would when cloning out a tripod leg in a wide-angle shot. In audio there isn't really a clone tool; instead you just make a copy of the track, offset it a little bit (as long a visual sync isn't an issue) and edit into the sequence. Place a short cross dissolve between the edits and the fix should be seamless.

Brief distracting sounds can be dealt with by copying a nearby portion of the track and using it to replace the bad section.

AUDIO CLICKS AT EDIT POINTS

Audio is recorded digitally, so when you cut two audio clips together, the digital bits don't always line up exactly. This can result in a slight click sound at the edit point. What is frustrating is that the click doesn't show up in the original files—only files that are edited together. This doesn't happen often, but it is something to keep in mind.

Solution: This is an easy solution. Place a quick audio dissolve (or crossfade) at the edit point. A quick rate—2 or 3 frames—eliminates the click.

Brief distracting sounds can be dealt with by copying a nearby portion of the track and using it to replace the bad section.

audio types

Ambient sound is the natural sound that occurs at any given place. It is good to be aware of what that sound is and record it for audio editing purposes.

AMBIENT

As we discussed in Chapter 7, ambient sound is natural noise that occurs from and around your subject, and ambient audio is a recording of that sound. Ambient audio is an important part of video; it creates a sense of realism and authenticity in your scene.

Ambient sound is very difficult to re-create, so much so that if the natural sound recorded on a track is not very good, you might need to replace the sound completely with music, a narration track, or both.

Good ambient audio is important for editing. As you start editing the video and audio for your movie, you will quickly learn how important it is to have good audio coverage for editing. It won't take long to get frustrated if you have too few options. Sometimes ambient audio is the audio that is recorded when you record the video, this is often also called sync sound, as in the audio is in sync with the video. Other times you will record ambient audio separately.

MUSIC

Music is an important part of making videos. It is also very misunderstood as to what music you can and cannot use, and when from a copyright perspective. You can use almost any music you want with your video if you are using the video for personal purposes and you never show it in front of a paying audience—this means an audience who pays in any way for attendance where your video is being played, including if you were selling products at an event where the admission is free.

There are severe copyright restrictions for using music in any other way. Don't think because you are a small-scale video producer that it won't matter. The music industry has a history of going after even very small businesses down to individuals if they think copyrighted music has been used without proper licensing.

Plus, respecting copyright is the right thing to do. You wouldn't like it if someone stole your video, your images or your camera for their own use just because it was easy to do. This is such a tricky area that the best advice is to respect copyright and never use copyrighted music on a video unless it is purely for personal use or in a classroom or educational setting.

There are advantages to using music that is not popular or even familiar. It may seem great to use a U2 or Norah Jones song with your visuals, but these songs are so identifiable that the audience hears this song rather than sees the film. Most importantly, though, it's illegal to use copyrighted music without permission. So how do you find music you can use? There are several sources that you can utilize to get good music for a video:

Sonic Fire Pro is a program that uses SmartSound music to build music for specific uses. SmartSound music can be used with any videos. The music is selected by things such as music style and tempo, plus it can be built to any length needed.

Royalty Free: Look for something called royalty-free music. This can be a number of things. It can be free music that has been created specifically for video productions and other uses; it can be music that is designated as a creative commons usage; or it can be music that exists in the public domain.

Local Musicians: Another source of music is local musicians. Most communities have talented amateur and would-be professional musicians who are looking for exposure and ways to promote their music. Many musicians are willing and excited to help you with music for your project.

One thing to keep in mind is that you cannot simply take a copyrighted song and have a musician record it. It is still a copyrighted song. Use original music or some form of non-copyrighted music

Create Loops: Some editing applications with advanced audio mixing modules provide audio loops that allow you to create your own music. They are called loops because they are short lengths of audio that are easily repeated to get the total length that you need. They require some music skills to get right. Start with a percussion track and add guitar, bass, and some saxophone—with a little editing, you have a music track.

Local musicians are a good source of inexpensive—or even free—music.

MUSIC AND VIDEO

Once you have found a music source, think about how the music will work with your video. If you edit a bunch of video clips together and simply slap some music on top of it, there is no guarantee that it will look or sound good. Pay attention to the music and how it works with video. Here are some things to think about when choosing music:

Music can have a big effect on how a viewer sees your video. Imagine this scene with bluegrass music, then think of it with Beethoven's 7th Symphony.

Music Affects Mood and Emotion: There is no question that music affects how an audience responds to the video. Hollywood filmmakers know this, which is why they spend so much time choosing and composing music. Whether you choose fast, upbeat music or slow, contemplative music, you can change how viewers will respond to the video. Think about how you want your audience to perceive your video and choose the appropriate music.

Rhythm and Beat: A fast-paced rhythm with a heavy beat works well with fast-paced video and lots of action. The same sort of music is going to fight with gentle video in slow transitions. The reverse is also true. Gentle music will not go well with fast-paced video and lots of action.

Edits on the Beat: There aren't steadfast rules for editing to the music's rhythm, but there are issues. Lining up every edit with the music's beat can lull your audience into a set rhythm. Sometimes the beat is so fast that cutting on each beat will give the audience fatigue at looking at so many shots. Plus, editing the cuts to sync with the beat emphasizes the music rather than the video footage.

Music Covers Audio Problems: There will be situations where you have to shoot video in bad audio situations, such as recording waterfowl in a beautiful pond that happens to be right next to an Interstate highway. Sometimes, the only way to be able to use the video you have shot is to replace the sync audio (that shot with the video) with music.

Link Clips: You might have a section of a travel video that shows the first day on location and then you go to a segment of video about the architecture. Music can act as a bridge to link those sections or as a continuous background that flows behind both clips.

Avoid Nonstop Music: This really depends on how long your program is and what you're trying to do with it. If you have a short video with lots of scenes from a birthday party, for example, you might create a simple 3-minute video with music and visuals, and that is fine. But if music is behind everything all the time—especially good natural sound or someone talking—it can sound forced and feel boring.

NARRATION

There may be times where the ambient sound and images aren't enough to tell a story. Narration is a common technique used to help the viewer understand the video's context. A narrator can guide the viewer through a location, a story, an event, and so on.

You can record a narrator in the field, but this could also mean recording the ambient sound on location. Instead, record in a quiet room. You can use the same audio techniques to record a narrator that you do to record other audio. Some editing applications allow you to record narration right on the computer. However you choose to capture the narration, make sure the recording is good quality. Try these ideas to make the narration sound its best:

- The narrator should be standing. This allows for good breath support so the narrator doesn't run out of air at the end of a sentence.

- Type up the script and print it in type large enough that your narrator can read it easily. Put it into paragraphs and use proper punctuation so that the narrator can put the emphasis on the right words.

Narration is an important aspect in many videos, and it must be recorded carefully for best effect.

- If possible, place the script on a flat surface near the narrator and record one page at a time. This prevents paper shuffling noises being recorded in your track. Keep the script away from the space between the narrator's mouth and the microphone.

- Take your time recording the narration. Record the whole track once and then go back and recording it again. This allows the narrator to become more familiar with your words.

- Record a temporary narration track to hear how the spoken words affect your edits and judge what works and doesn't work.

- Remember that you can't layer audio tracks on top of one another without adjusting the levels. For example, if you have background music playing on your track, you'll have to lower or "dip" the music level when the narration starts so that your audience can hear the narrator.

SOUND EFFECTS

Sound effects are used to emphasize an element in a scene, to represent something that happens off screen, or to even accentuate an edit. A scene of a lone cannon on an historic battlefield might need the sound of cannon fire to conjure up long ago battles to your viewers. An off-screen sound of a door closing can be a substitute for actually having to show a person leaving a room.

Some editing applications have simple sound effects, like doors closing or cars starting up. The previously mentioned SmartSound is a great resource for sound effects, and a simple search on the Internet will uncover several links for free sound effects. You can also go out and shoot your own sound effects using the same gear you use to shoot other audio.

VIDEO OUTPUT

This is the last chapter in the book, but in many ways, it could be the first. How you intend to share your movie impacts the kind of equipment you use, how you use it, how you edit the video, and how you mix the audio. The number of options for viewing videos increases every day, so try to think about what will make the maximum impact.

SPECS

While the number of output presets offered in editing applications makes it seem like outputting is a button-push away, you do need to work at it. When you print an image on an inkjet printer, it often takes several attempts to get a satisfactory result; the same is true for outputting video from the computer. Unless you are playing back your movie directly from an editing application, you need to prepare the video files to play on your chosen medium.

RESOLUTION

When outputting an image file for printing, the resolution is determined via the dots per inch (dpi) or pixels per inch (ppi) setting. With video, you don't have control of how many pixels make up a certain portion of the image area—the display device determines that. What you can control is the pixel count—specifically, the number of pixels in a row and the number of pixels in a column. Your original HD video resolution might be 1920 x 1080 or 1280 x 720, but when you go to output—depending on the device—the resolution might be 1920 x 1080 or 1280 x 720, or it might be something smaller, like 320 x 180. Just like resizing an image in Photoshop, outputting to a lower resolution requires creating new pixels. Watch the movie carefully to make sure the new pixels maintain a good representation of the original file.

FRAME RATE

The frame rate with which you shot your video is the same rate you'll use to edit the footage. This is 59.94, 29.97, or 23.976 frames per second (fps) in North America and Japan, or 50 or 25 fps outside of North America. It is likely that the display devices that you are outputting for can handle all of these frame rates, but then again, they might not. You must know the specifications of the display device, and output your video based on those specs.

QUICK TIP

Pulldown

If you use 23.976 fps, you might have to convert your file to add frames so that you end up with 29.97 fps. Adding frames is a technique called a pulldown. If you are outputting for online use, most sites accept 23.976 fps. With optical discs like DVD and Blu-ray, you can keep the file at 23.976 fps; the player will add the pulldown. This method, as opposed to adding the frames yourself, helps keep the file small so you can get more on a disc.

DATA RATE

HD video requires a good deal of bandwidth. Think of bandwidth as the number of lanes on a highway. The greater the number of lanes, the more cars can get through. Bandwidth is specified by the data rate of the device, expressed in bits per second (bps).

All devices—from your computer's hard drive to a broadband Internet connection, from a Blu-ray player to an iPad—have a maximum data rate that they can handle. If you try and play back a file that requires a data rate higher than the maximum on any of these devices, you'll experience stuttering frames or dropped audio, or the file might not play back at all. Some devices have published data rate specifications and some do not. With the latter, a bit of trial and error is required.

Data rate is applicable to both video and audio. Some output mediums might specify their maximum data rate in terms of video and audio combined, like DVDs, which have a maximum data rate of 9.8Mbps. This means that the total data rate of video and audio in a movie file that you output for DVD can't exceed 9.8Mbps.

QUICK TIP

Data Rate or Bit Rate

Data rate is specified in terms of bits per second, which is why it is sometimes called bit rate. Video bit rate is usually in the millions, and is abbreviated as 1.5Mbps—which is read as 1.5 million bits (or megabits) per second. Since audio data is smaller, bit rates are usually in the thousands and are expressed in kbps (kilobits per second).

AUDIO

You have worked hard to create a good audio track for your movie, but the speakers that you are listening to are not necessarily the same as those used by your audience. There are hundreds of options for listening to audio playback. A Blu-ray disc that plays in a home theater with 5.1 Dolby Digital surround sound is quite different than something that plays on an iPhone without earbuds. In the home theater, the audience can pick out the nuanced cries of the loon in the background audio of your opening shot, whereas the iPhone user may never even hear the loon. Once you output and test the audio playback, you may find that you need to remix the audio tracks for different playback devices. Again, there are no general rules here. This process is a lot of trial and error.

An aspect of audio that you cannot avoid during output is the sample rate. Video has a frame rate, and audio has a sample rate. The sample rate describes how many times per second the audio is evaluated and recorded to a digital number. For high quality audio, there are two different sample rates, expressed in kilohertz (kHz). Most video devices sample the audio 48,000 times per second—48kHz—while CDs and MP3s use 41,100 samples per second—41.1kHz. Changing between 48kHz and 41.1kHz is hardly noticeable, but avoid going back and forth between the sample rates as much as possible. For some devices and online presentations, you may need to compress the sample rate to a slower frequency.

ASPECT RATIO

Regardless of the screen size you use to present the final product, you must know the display device's aspect ratio. For example, if you want to show something on a website, the default video player window is most likely set for a 4:3 aspect ratio. Since an HD video file is natively 16:9, you have a decision to make. You can make a center crop of your video, which is an HD video that loses the left and right areas of the composition, but fills the screen. The other alternative is to letterbox your movie by shrinking it so that the video's entire frame is visible. This leaves a black bar along the top and bottom of the screen; the advantage, of course, is that no cropping occurs.

Some video players—online, on a computer, or on a DVD player—include an aspect ratio correction feature. All you need to do is deliver a 16:9 aspect ratio. For example, YouTube now accepts 1920 x 1080 (which is 16:9), and will display the aspect ratio properly. A properly authored DVD or Blu-ray disc displays according to the player's configurations. If the player is connected to a 4:3 display, the video is configured to automatically letterbox a 16:9 video. For connection with a 16:9 display, the player uses the video's native format.

QUICK TIP

1.77777778

If you are outputting a movie to a new pixel resolution, make sure that the numbers add up! For example, if you are editing a 1920 x 1080 sequence and need to output for a website, make sure that the new pixel dimensions have the same ratio as the original. In other words, 1920/1080 = 1.77777778, so if you want a movie that is 480 pixels wide, the final movie size should be 480 x 270 (480/270 = 1.77777778).

QUICK TIP

Pixel Aspect Ratio

You may run across the term "pixel aspect ratio," or PAR, when compressing files. If you were to take a magnifying glass to your computer screen and look at the individual display pixels, you would see that they are square. In the early days of digital video capture, the pixels weren't square—they were rectangular. This meant that the pixel aspect ratio wasn't 1:1; the width of the pixel was more than the height. Therefore, the pixels had to be modified during output. With HD video capture, the pixels are almost always square, so if you see a pixel aspect ratio setting in your camera or editing software, make sure it is set for a 1:1 pixel aspect ratio. This may be expressed as any of the following, depending on the manufacturer: 1.0, 1:1, or square.

SCREEN SIZES

How you display an image, still or movie, impacts the viewer's response to it. The display size can range from the screen on a cell phone to a large screen showing the output of a video projector, and like prints, your final display size affects how you produce your video.

What you can see in a small screen is very different than what is visible on a large screen.

SMALL SCREENS

Small video display platforms—like a phone, a portable video player, or a website—generally use image resolutions that are a fraction of the resolution of HD video, and even a fraction of standard definition resolution for that matter. An iPhone 3GS, for example, has a screen resolution of 480 x 320 when viewed horizontally.

At that small size, nuances disappear. A single tear on a person's cheek or the flicking tongue of a snake is hard to see unless you plan for it in advance. If you are producing video for a very small screen, include more close-ups in your shoot and edit. If you are using type, make the font large, bold, or both. A sans serif font is easier to read on such screens.

When it comes to planning for audio, the viewer might use the built-in speakers on the phone or computer, or they might use earbuds,

headphones, or an external sound system. Each of these setups produces a different quality of audio fidelity; and, there is a big difference in listening environment between headphones and the built-in speaker of a cell phone while standing on a busy sidewalk.

MEDIUM AND LARGE SCREENS

The audience can see all the details on a large computer display or television. Minor things—such as dust on the image sensor—might be invisible on the small screen, but become very apparent on a larger screen. In general, mistakes are hard to hide on a medium (or large) screen.

Also, be aware of your edits. Quick edits get overwhelming, particularly if the cuts are between very different visuals. For larger media, such as projector screens, try to view your edit on the same size screen to see how your editing works. That doesn't mean you have to hook up a projector to see how every cut looks; just view it when you have a first rough edit done.

If you are outputting for a large screen, you can usually assume that it is attached to a good quality audio system. Large screens in a home theater have excellent audio quality.

QUICK TIP

Stick with common video sizes. Many video drivers are optimized for playback of standard size HD video—like 1920 x 1080 or 1280 x 720—and struggle with scaling non-standard-sized video on the fly.

These systems will magnify any errors in your audio mix. If you don't have access to a home theater system to listen to your output, consider listening to your output on high quality headphones (not earbuds) to block out any ambient noise so you can really hear the mix.

compression

It is unlikely that you will use your editing computer to playback your movie for audiences. Unfortunately, few devices have the playback performance that your editing computer probably has, so you'll need to compress your movie. Compression schemes optimize a video file to play on a specified device by reducing the data (or bit) rate of a video file.

Just like capture codecs are optimized for recording to a memory card and not for editing, editing codecs are not optimized for playback devices. When you go to share your video, you'll need to compress using an output codec into the best format for your chosen display device.

WHAT'S THE RIGHT CODEC?

Which is the correct compression choice for playback? The answer is: It depends on the device to which you output. Compression is handled with a codec. A codec, as we discussed in Chapter 2, is any technology that can compress or decompress data—in this case, video and audio data. Because video files are so large, they almost always need some kind of compression to reduce the data rate. New codecs are constantly developed, so it is impossible to make a recommendation on the right one to use for every situation. The most common codecs used today are H.264, MPEG-4, and VP-8.

FORMATS

Playback formats can be confusing. Often, someone will ask for a QuickTime or Flash movie or an AVI or Windows Media file (WMV), but none of these names really says much about how you deliver the video file. They say nothing about resolution, frame rate, or even codec, and completely ignore audio information. Think of QuickTime, Flash, AVI, or WMV as boxes or containers that hold your video files, and that the files inside can be compressed, using different codecs, to fit into those containers.

For instance, if someone asked you for a QuickTime movie, you could create an uncompressed 1920 x 1080 file with multiple audio tracks, or a 320 x 180 H.264 with mono audio. These are very different files, but they both fit the parameters for QuickTime.

AUDIO CODECS

Audio needs to be compressed, too. Audio doesn't take up as much space and bandwidth as video does, so the compression isn't quite as complicated. Audio codecs are typically the MP3 codec used for music players, or AAC, which is the standard for the Apple iPad, the Sony Playstation, and other similar devices. AAC is not as compressed as MP3 and offers higher-quality audio. When outputting multi-channel audio for DVD and Blu-ray, it is necessary to use the Dolby Digital AC3 codec.

THE GOLDEN RULE OF COMPRESSION

Compression is not a one-size-fits-all process. This cannot be emphasized enough. A compression method that works for one video program may not work as well for another. Always watch the video completely once the file has been compressed so you can judge the results and adjust things if necessary.

Compression is a compromise of video and audio quality, file size, and data rate. Each of those factors will vary depending on the video's content and the hardware needs for playback. Quick edits, pans across detailed scenes, and noise issues are just some of the breaking points for compression, but there is no set formula. You'll probably need to tweak compression settings to find the best compromise.

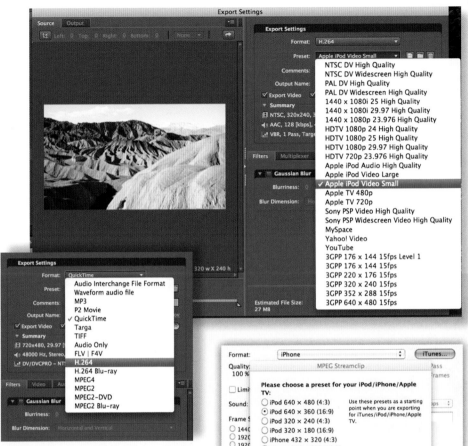

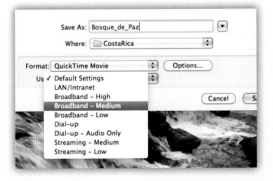

COMPRESSION TOOLS

Most editing applications available today include compression tools for HD video. These tools often have specific presets, and this is a good starting point. There might be an iPod Touch preset, for example, in the export settings of a given application. Start with some common presets to see how your video looks. You might be able to modify the preset to increase the data rate or compression quality if you aren't happy with the first results.

View the movie on the device and in the environment your viewer will use. A video compressed specifically for an iPhone should be viewed on an iPhone, not just on the computer. If you don't have a choice, try a device emulation program. It won't be perfect, but at least it will get you closer.

While there is no substitute for viewing your video on the device, Adobe has an emulator you can use.

Free Compression Tools: There are other free alternatives for compression available for both Mac and Windows. MPEG Streamclip (www.squared5.com) originally accepted only MPEG files, but now it accepts QuickTime and WMV files, too. Another application, HandBrake (www.handbrake.fr), has similar capabilities. Both applications offer batch conversion so that you can compress multiple movies with the same setting. This is useful if you know it will take time to compress a movie; it makes it easier if you can set several files to compress overnight.

A preview window is also standard in each application. While the preview window isn't the best way to determine compression quality, it is useful to ensure that the resolution and aspect ratio are properly set.

These applications, like many editing applications, offer presets, including compression methods for various mobile devices, like the iPhone and iPod Touch. MPEG Streamclip takes things a step further by offering compression beyond H.264, MPEG-4, or pretty much any codec you have installed on your computer. MPEG Streamclip is also a useful tool if you need to convert your movies to a more editing-friendly format before you start editing.

WEB OUTPUT

If your video is destined to live online, consider the requirements of the website. Some sites might require a specific QuickTime file, or they may ask for WMV or Adobe's Flash format. You may create the final compressed file that everyone will view, or you might send in a higher-resolution file that the website host compresses for their specific delivery system, so be sure to find out the website's submission requirements before you output the final file.

FILE FORMATS

There are three main file formats that you can deliver for online viewing. Each of these formats can use different codecs, both for video and audio.

QuickTime: QuickTime is Apple's ubiquitous media platform. It is an extremely flexible format, used for content creation and distribution. The list of codecs available is almost endless. While the creator is Apple, it is a cross-platform format. Direct your viewers to download the QuickTime player plug-in. If you are producing content for a PC-based organization, be aware that QuickTime might not be an available download due to company firewalls, and they may have problems with QuickTime files playing in a Windows environment. For these reasons, you might need to create a WMV file for compatibility purposes.

Flash Video: Flash is Adobe's video platform and has a large installed base. Flash started out as a method of bringing animation to web pages. It was optimized for compressing vector-based files (files made up of mathematical algorithms rather than pixels) and delivering them across slow Internet connections to bring life and interactivity to websites. It uses a few different codecs, including H.264 as well.

Unfortunately, compression tools for Flash are not as common. If you are using Adobe's Premiere, it will be easier to generate a Flash file. If you are not using Premiere, you will need an open-source compression tool, like FFmpeg, to create the files. FFmpeg is an open-source compression tool for Flash files created on a Mac operating system (www.ffmpegx.com). With Windows, consider the Flash converter from SourceTec (www.sothinkmedia.com).

The end result of Flash compression is an .flv file, which requires embedding in a "Flash player" in a website. While Adobe's Flash player has a large installed base, the installations don't always include support for the latest codecs and, like QuickTime, firewalls can prevent them from being installed.

QUICK TIP

Silverlight

You may run into the name Silverlight. This is Microsoft's version of Flash. It is not a new codec; it is a web application that offers media coupled with interactivity. It uses WMV9/VC-1 codec.

Windows Media (WMV): Windows Media is Microsoft's answer to Apple's QuickTime. The format uses Microsoft's custom-designed codecs that also carry the Windows Media name. It is a little confusing to think that a file is also a codec, but that is the way it has developed.

The Windows Media player is usually installed as a part of any Windows installation. If you are using Premiere or Vegas, you can export to Windows Media. If you are using a Mac application, you need to buy Telestream's Flip4Mac plug-in to create WMV files.

Audio Video Interleave (AVI): AVI is another Windows format that is used in some applications. It is not as popular as any of the above formats and is rarely seen in relation to output for the web or other devices.

QUICK TIP

File types, file formats, and containers! Oh my! Unfortunately, these terms are bandied about by different applications and websites and can make for a confusing world. For example, YouTube specifies their preferred "containers" as FLV, MPEG-2, and MPEG-4. Vimeo specifies their preferred "format" as MP4. They are both talking about the same subject, but Vimeo is actually referring to the extension of the file—for example, MyMovie.mp4—which is an MPEG-4 container. Some containers can contain many different elements, like audio and video and subtitles, in many different codecs. This makes containers flexible but also confusing. Don't let the variants in terminology trip you up.

PREPPING FILES FOR PLAYBACK

For most websites, you might supply the finished file for playback rather than submit a high-resolution file to the website owner to do the conversion. You'll have to ask them what they need. You'll need to determine resolution, codec, audio rate, frame rate, and data rate.

If you don't have any information on delivery specifications, a good starting point for creating videos for websites is to create two files: one for a small window size (480 x 270) and one for a large size (1280 x 720), which should come close to filling the screen on some computer displays. Try H.264 for the codec. For the 480 x 270 movie, set the data rate to 1.1Mbps if possible; for the 1280 x 720 size, use 5Mbps. For audio sample rate, maintain your sequence sample rate and the data rate can be either 96kbps or 128kbps. Lastly, make sure the frame rate is the same as your original edit. If you were editing at 29.97 fps, make sure your output movie is 29.97 fps.

AUTO CONVERTERS

If all this starts making your head dizzy and you have a choice as to how the online video is displayed, consider using YouTube or Vimeo as your video playback solution. These sites take your video and compress it into several versions: a version that people can view on slow internet connections—which usually means standard definition video—and versions compressed for high definition playback on high-speed connections. These sites offer free and paid services (the free service entails uploading limits based on file size or clip length) and they are simple to use.

Once uploaded, you can point viewers to the video on YouTube or Vimeo; or you can

embed the YouTube or Vimeo player on your website so that viewers don't have to leave the site to watch the video. YouTube and Vimeo convert your video file to their own particular specifications, which includes lowering the resolution. What you upload is not what viewers will see when it is finally available. Give YouTube and Vimeo the best possible quality that they can then compress.

YouTube: YouTube currently asks that you upload a high definition file with a 1920 x 1080 or 1280 x 720 resolution. Choose the one that most closely matches your edited sequence. If you are editing in 1280 x 720, don't upsize it to 1920 x 1080 before you upload. YouTube will accept the native frame rate, so if you shot and edited at 23.976 fps, keep it that way. As far as a codec, it accepts just about any codec, and they are adding new ones every day.

Audio is a part of the equation too. AAC or MP3 works for audio codecs and they require stereo or mono, rather than surround sound (5.1) audio, with a sampling rate of 44.1kHz. The maximum file size you can upload is 2GB.

Vimeo: Vimeo prefers you scale 1920 x 1080 video files down to 1280 x 720; they will do that themselves anyway. They also prefer the H.264 video codec and AAC audio codec. When you output the file that you will upload to Vimeo, make sure the data rate doesn't exceed their specs. Vimeo limits bandwidth so that the data rate does not exceed 5000kbps for video and 320kbps for audio. The biggest file you can upload with their basic service is 500MB.

QUICK TIP

Online services like YouTube and Vimeo are constantly upgrading their sites. Their tips for uploading videos recommend specific settings. They might suggest a maximum data rate in addition to a maximum file size. You can experiment with the data rates, increasing them until you reach the maximum file size. This ensures that you will submit the highest quality video possible.

WRITING DISCS

Optical discs offer convenience and quality that most other devices lack. Creating discs takes more work on your part, but the simple operation makes it easy for viewers to watch your movie.

STANDARD DVD

To create standard DVDs, you must take your HD movie and compress it to standard definition resolution. The video codec is MPEG-2 and the resolution is 720 x 480. Audio can be Dolby Digital AC-3 or PCM, the former being more common.

There are various bit rates you can use that are based on the total length of your video. A single-sided, single-layer DVD can hold about 4.7GB of data. Depending on the data rate, this could store two or three hours of video. Data rates for DVDs range from 2 – 8Mbps. Even if you have a limited amount of video to place on a DVD, you should still keep the bit rate around 6.5Mbps. Some DVD drives might run into problems trying to maintain a data rate higher than that without stuttering. The quality at 6.5Mbps is still quite good.

If you store over two hours of footage, the data rate starts approaching 2Mbps and the video quality of the compression becomes more noticeable. If you don't want to increase the compression rate, then you have two options: use multiple discs, or use dual-layered DVDs.

The dual-layered DVD requires more planning. At some point during playback (especially if the video is one long movie) the player will briefly freeze the video while the laser beam inside the drive is refocused in order to read the other disc layer. If you are burning several movies to the disc and the "layer break"

happens between movies, it will be invisible to the user. Dual-layer discs that you burn yourself can sometimes have playback problems; if you have multiple movies, consider using two discs rather than a dual-layer disc.

QUICK TIP

Authoring

DVDs require some authoring so that they play properly. "Authoring" is the process of creating the user interface for the disc—the DVD menu—and linking it to the audio and video files. You can author a disc without a menu—the viewer just presses the play button, or you can have the disc play automatically—but most people are used to seeing a menu appear when a disc is inserted into a DVD player. Most DVD-burning applications, like Roxio Creator (Windows) or Roxio Toast (Mac), include authoring tools and templates, as well as some video-editing tools.

BLU-RAY

Blu-ray is the HD replacement for DVDs. Right now, it is the only "universal" format for HD video playback on an optical disc.

The Blu-ray disc holds 25GB of data in the single-layer version and 50GB in the dual-layer version. Unlike DVDs, which only allow one type of video codec (MPEG-2), Blu-ray accepts three different codecs: MPEG-2, H.264, and SMPTE VC-1. (H.264 is also referred to as MPEG-4 and AVC.) The MPEG-2 codec limits you to about 120 minutes of HD video on a single-layer disc, while the other two options double that amount. The audio codec is either AC-3 Dolby Digital or DTS.

Some of the same software tools for creating DVDs can also be used to create Blu-ray discs. Just like DVDs, they require an authoring process in order to create menus and functionality that viewers can use. Also, Blu-ray players can play DVDs, so even if you don't have access to Blu-ray discs, you could still create a regular DVD and watch it using a Blu-ray player.

Device-Specific Output

As you have likely gathered by now, each separate device needs different compression settings. Some devices might be optimized for a particular codec. Others might be able to resize the image without any stuttering. You always have to keep the playback device in mind when you begin the output phase of your movie adventure.

COMPUTER PLAYBACK

If you want to deliver your video for computer playback—like a laptop connected to a video projector—you'll need to test and evaluate the performance of the computer. With computer playback, you aren't limited to the bandwidth of an Internet connection, but you are limited by the computer's speed. How quickly the computer can read the data off the hard drive or optical disc, and how efficiently the computer's CPU or graphics card can decode the video file, can impact the quality of your movie. Newer computer processors are optimized for H.264 playback, but the video file resolution and compression is still a factor.

Another consideration is any device you have attached to the computer to display the movie. The projector or monitor must be able to display HD video. You have to consider both devices—the computer and the monitor—when determining the movie's final resolution. Base your decision on the lower resolution between the two devices.

HANDHELD MEDIA PLAYERS

Devices like the iPod Touch, iPad, Playstation Portable (PSP), and cell phones have their own video requirements and capabilities. Just like differing websites, there is not one portable player compression scheme to rule them all. An iPod Touch can accept 640 x 360 H.264 with a data rate of about 1.6Mbps, but also accepts the 480 x 270 resolution. Meanwhile,

a PSP looks for something like 480 x 270, also in H.264.

In order to determine the best compression settings for video players, check the manufacturer's website to see which audio and video codecs, resolutions, and data rates they support. Once you have that information, test, test, test.

ARCHIVING

Once your program is edited, compressed, and delivered, think about how you will archive—or back up—your project. If you aren't recording to tape, your original footage only exists on the computer, unless you backed it up before editing. If you don't archive your work, you could lose it. Remember that a good archive is one that works.

GUIDELINES

Archiving video is similar to archiving images, with some exceptions. These are the things to keep in mind as you develop your archival system:

Remember File Size: One of the other differences archiving video projects from stills is the size of files. The file sizes can be pretty large; the larger the video project, the more limited your options for archival medium. You can use DVDs but you'll probably need several, or you'll need to use dual-layer discs. As we mentioned before, dual-layer discs are not quite as reliable as single-layer discs (but this is improving).

Archive all Files: Video projects contain more elements that need to be archived—you don't just archive the raw footage. Any good video archive has the project file, original camera footage, audio files, music tracks, and any graphics files used in the video. You can also archive any render files the editing application creates for playback, but in general these are large files that can be automatically recreated when you reload the project into the editing application.

Maintain the File Structure: Don't rename or reorganize files on the hard drive during the archive process or, for that matter, once you've started your edit project. You want to keep the structure the same in the archive. If you imported your camera originals into folders by date before you started editing, keep them that way in the archive. This way the editing application will be able to find all the files if you need to restore the project.

SYSTEMS

Backing up depends on your editing application. Some editing programs have built-in archiving or media management features, but many do not. If your program includes archival settings, then follow those instructions. If your program does not include archive features, you can use similar techniques to back up your video project that you use to back up your photographic images at the file system level. The biggest difference between archiving with editing software and archiving at the file system level is locating the video project files. Editing software locates these files for you automatically, but you need to locate all of the video project files on your

computer's hard disk to archive at the file system level. If you have kept everything organized from the beginning, this step shouldn't be difficult. Then, follow the steps you would use to archive your still images.

MEDIA

As mentioned before, dual-layer DVDs are not quite as reliable as single-layer discs, but this is getting better. You could also use Blu-ray discs that hold a lot more information—nearly six times as much as a single-layer DVD. Obviously you need a Blu-ray writer, which is becoming a standard feature on Windows hardware, but not on Mac. However, you can easily attach an external FireWire Blu-ray writer to a Mac.

If there is no provision for archiving and burning to optical disc via your editing software, then you'll need to archive and burn using a third-party application, like Roxio Creator or Toast. You can burn some discs via the operating system but a separate application is more fool proof, and a Mac can't burn Blu-ray without a third party application. Writing to the disc on a Mac or Windows machine is a drag and drop procedure. Remember that these are data DVDs and are not formatted for playback in a DVD player.

A last option is to purchase an external FireWire or USB hard drive and connect it to your computer. Then simply copy your files (drag and drop) to the external hard drive. Then put the drive in a secure place. While a hard drive does not have the reliability of optical media, it is quickly becoming a method of archiving as files become larger and larger.

ARCHIVE TEST

The best way to test whether an archive works is to restore it. Temporarily rename the original folders and video project files so the computer thinks the old project is gone and you are restoring it. Then, copy the files back to your hard drive from the external drive, start up the project, and see if everything is there. While you might not do this test with every archive, you should do it when you create your first archive to make sure the workflow is correct. Test it occasionally to make sure the process works the way you expect.

QUICK REFERENCE: OUTPUT SPECS

ONLINE

YouTube

Resolution: 1920 x 1080; 1280 x 720

Frame Rate: any normal D-SLR frame rate

File Type: F4V; FLV; MPEG-2; MPEG-4

Codec: H.264 (and more)

Data Rate: any rate as long as max. file is below 2GB (at least 6Mbps)

Audio Codec: AAC; MP3

Audio Channel: mono; stereo

Max. File Size: 2GB/10 min. (basic service)

Vimeo

Resolution: 1920 x 1080; 1280 x 720

Frame Rate: any normal D-SLR frame rate

File Type: MP4

Codec: H.264

Data Rate: 5000kbps for video/320kbps for audio

Audio Codec: AAC

Audio Channel: stereo

Max. File Size: 500MB (basic service)

OPTICAL DISCS

Standard DVD

Resolution: 720 x 480

Frame Rate: 23.976 fps; 29.97 fps

Codec: MPEG-2

Data Rate: 4 – 8Mbps (anything below 4Mpbs looks bad with a lot of movement)

Audio Codec: AC-3; PCM

Audio Channel: multichannel

Max File Size: 4.7GB/1 – 2 hours (anything above 1 hour, 45 minutes requires more compression)

Blu-ray

Resolution: 1920 x 1080; 1280 x 720; 720 x 480

Frame Rate: 23.976 fps; 29.97 fps

Codec: MPEG-2; H.264; VC-1

Data Rate: 4 – 8Mbps

Audio Codec: AC-3; DTS; PCM

Audio Channel: multichannel

Max. File Size: 25GB single layer/50GB dual layer

HanDHeLD DeVICeS

iPad

Resolution: 1280 x 720 or smaller

Frame Rate: any normal D-SLR frame rate

Codec: H.264, but needs specific iPad metadata to guarantee playback (applied automatically when imported through iTunes)

Data Rate: 5Mbps

Audio Codec: AAC

Audio Channel: multichannel

iPod Touch:

Resolution: 640 x 360; 480 x 270

Frame Rate: any normal D-SLR frame rate

Codec: H.264, but needs specific iPod Touch metadata to guarantee playback (applied automatically when imported through iTunes)

Data Rate: 1.6Mbps

Audio Codec: AAC

Audio Channel: multichannel

PSP/PSP Go

Resolution: 480 x 272

Frame Rate: any normal D-SLR frame rate

Codec: MPEG; MPEG-4; H.264

Data Rate: approximately 1Mbps

Audio Codec: AAC; MP3

Audio Channel: mono, stereo

iPhone 4G

Resolution: 1280 x 720

Frame Rate: any normal D-SLR frame rate

Codec: H.264, but needs specific iPhone metadata to guarantee playback (applied automatically when imported through iTunes)

Data Rate: 1.6 – 5Mbps

Audio Codec: AAC

Audio Channel: multichannel

HD VIDEO GLOSSARY

1080 and 720 – high-definition video formats. 1080 has a resolution of 1920 x 1080 pixels, and 720 has a resolution of 1280 x 720. Each video frame is transmitted in a single sweep, known as progressive scanning, which is signified by "p". 1080 can display all HD video formats without sacrificing any picture detail.

120Hz refresh rate – consumer HD television feature where the image is refreshed at a faster rate than the frame rate of the video. Pixel interpolation is used to smooth out on-screen motion.

35mm sensor – an image sensor size that is approximately 36 x 24 mm, with an aspect ratio of 3:2. These sensors are found in many high-end D-SLR cameras.

16:9 – see Aspect ratio.

4:3 – see Aspect ratio.

3rd Party Software syncing – a method of aligning an audio clip to a video clip that requires the videographer to record a reference track in-camera. During the editing process software will compare the waveforms of the two audio tracks and adjust the sync.

ambient sound – the natural sound that occurs at any given place, often surrounding your subject.

anamorphic video – wide screen video shots that have been compressed to fit a narrower video frame for storage on DVD. The display device must, in turn, expand these images. Displays with a 16:9 will be able to show these images in the original proportions.

APS-C sensor – a sensor size that is approximately 25.1 x 16.7 mm, with an aspect ratio of 3:2. These sensors are commonly found in D-SLR cameras.

archiving – the process of backing up your files, or saving them in multiple locations. This action ensures that if one of your files becomes corrupted or lost, you will still have a copy of that file elsewhere for use.

artifacts – unwanted visual effects in an image created by irregularities that may occur throughout the process of creating a movie. "Pixelation" and "flare" are examples of this.

aspect ratio – a ratio that notate the measurements (width:height) of a monitor or image. The National Television System Committee (NTSC) standard is the 4:3 ratio. HDTVs and HD video cameras use a 16:9 ratio, which is wider and better displays widescreen material.

ATSC – a set of standards developed by the Advanced Television Systems Committee for digital television transmission. Some standard definition formats are included in the standards, however ATSC standards were developed for US over-the-air television broadcasts.

audio – the aspect of the video related to sound, the broadcasting, reception, or reproduction of sound.

audio recorder – an external audio recording device often used as a supplementary source of audio during a video shoot. This type of recording equipment is often useful for recording ambient sounds.

audio transition – the change from one clip of audio to the next, often aligned with the transitions of video, but not limited to this alignment. Sometime an audio transition works best when it takes place a few seconds before or after the video transition.

audio syncing – a method of lining up a separate audio clip with a video and audio clip (in dual system sound) by laying them out in a sequence and listening. One track will be offset in time from the other. The editor moves or "slides" one of the tracks and listens again, and repeats this process until the two tracks are in sync.

Audio Video Interleave (AVI) – a video file format that is used in some applications, created by Microsoft.

authoring – the process of creating the user interface for a DVD or Blu-ray disc, and linking it to the audio and video files.

Automatic Gain Control (AGC) – this feature automatically increases or decreases the level of your audio recording.

bandwidth – see bit rate.

beanbag – a simple support for a camera that helps stabilize it in many conditions. This support is literally a soft bag filled with beans, but now, small plastic pellet are more common.

bit rate – measurement (in "bits per second") that expresses the rate at which data flows through a system. Higher bit rates allow for more data to be processed, and normally yield a higher picture resolution.

black level – the minimum brightness level of a scene.

Blu-ray – an optical disc read by a blue violt laser. It is the only "universal" format for HD video playback on an optical disc. It can also be used as a data disc for archiving projects.

boom – a jib or crane that holds a microphone closer to the sounds of a scene without showing the microphone in the scene. Also describes the act of putting the camera on the end of a long pole and moving the camera up and down.

chroma subsampling – the process of encoding images by using a lower chroma resolution than luma resolution.

chrominance – the color portion of a video signal. This includes information related to the hue and saturation of color portions of the image.

chronological sequencing – a method of sequencing video clips based on time from start to finish of an event or some action. This is often used when using video to tell a story so that the viewer follows the video and the story in chronological or time-sequenced order.

close shot/close-up (CS/CU) – a view that features mostly the subject, eliminating most of the surrounding environment and bringing the viewers focus to the subject.

codec – a computer algorithm that is used to compress files in order to save space. The term "codec" is derived from compression-decompression.

compression – a data encoding process that seeks to reduce the amount of data (bits) needed to represent a movie while limiting the amount of perceptual data that is lost.

composition – how a scene and its visual elements are framed within the image.

conceptual sequencing – a method of sequencing your video clips based on a particular concept.

contrast ratio – the measure of the difference between the darkest shadows and the brightest highlights in an image.

convergence – bringing video and still photography together in one camera.

coverage – shooting a variety of video in terms of types and lengths of shots to maximize the available content for editing purposes.

cutaway – a short shot used to move quickly from the main visual of a scene. Cutaways are used to give more context, detail, or information about a scene or subject, as well as an editing technique to create a more stimulating visual for the viewer.

data rate – the rate at which data moves through the system, usually measured in megabits per second (Mbps or MB/s). Also, see bit rate.

decibels (dB) – the measure of sound pressure level in an audio track.

Digital Living Network Alliance (DLNA) – a collaboration among more than 200 companies, including Panasonic, Sony, and Samsung. The objective of this collaboration is to create products that communicate to each other throughout your home. Some products may include Blu-ray players, and other high-definition video devices.

dissolve – a transition that blends the end of one clip into the beginning of the next clip. This creates more fluid transitions between clips.

Dolby Digital – an audio format. This format is the official standard for HDTV audio, and is usually associated with 5.1-channel surround sound.

dolly – a cinema-style move that brings the camera closer to or further from a subject; also, a tool used to smoothly move the camera from one spot to another within the scene.

dutch tilt/angle – a deliberate and extreme tilting of the camera so that the horizons are crooked and verticals are skewed. This is used often in action, thriller, and horror movies to increase tension, chaos, and drama.

editing – the process of selecting and preparing your video for viewing. This normally consists of a process of viewing, organizing, trimming, and sequencing of video clips, followed by the process of adding transitions and titles to the film.

emotional sequencing – a method of sequencing your video clips with the intention of causing your viewer to experience emotion. You may need your clips to build up to this emotion, or you may use different clips to give your viewer a break from potentially overwhelming emotion.

extreme close shot/close-up (ECS/ECU or XCS/XCU) – a view that is cropped into the subject to emphasize a specific detail. This type of shot may be used for dramatic effect.

fade – a common, dramatic transition that is often used in slow-paced edits. This commonly refers to a fade to black. The outgoing shot dissolves all the way to black, and the incoming shot begins at black and fades in. The time and color of the fade can be varied to alter the mood of the transition.

flash frame – a couple of frames of white or almost pure white inserted at an edit point.

Flash Video – Adobe's video platform, a file format that was optimized for compressing vector-based files and delivering them across slow Internet connections.

fluorescent lights – a type of light used for its portability; these lights are widely available and do not reach high temperatures, unlike other types of video lighting.

frame rate – the number of full images per second that are captured or displayed by a camera or media display device.

follow-focus controls – a large knob that connects to the camera lens by way of gears. This tool allows the videographer to focus on the action and follow it more smoothly and slowly.

footage – the amount or length of a film or video that has been shot. This is a shot, or series of shots, of a specific subject.

gain – a control on camcorders that amplifies the signal coming from the image sensor. It operates similarly to the ISO speed control on a D-SLR, except it does not use the same ISO numbers. Like ISO, as gain increase, so does noise in the image.

Gaussian blur transition – a transition in which one scene ends by gradually applying a blur effect until the scene appears to be mush, and then switches to an equally blurred second scene in which the blur is gradually removed.

headroom – the range of audio levels below the distortion point and above the normal audio level. A buffer zone before audio levels exhibit distortion. Also, headroom describes the amount of space between the subject and the top of the video frame when evaluating composition. If there is a lot of space, the composition is described as having too much headroom.

High-Definition Multimedia Interface (HDMI) – an audio/video interface (cable) used to transmit uncompressed digital information. HDMI connects audio/video sources, such as HD video cameras, to compatible display devices.

high-definition (HD) video – video that has a greater resolution than standard definition video, with internationally agreed upon specifications. HD is a widescreen format.

HMI lights – often used by professional video and film shooters, these lights are high-end daylight-balanced lights that are very expensive and dangerous if used incorrectly.

histogram – a graphical representation of the tones in an image, from shadows to highlights (left to right).

impact sequencing – a method of sequencing your video clips based on the unexpected. Sequencing your video clips in an order that your viewer may not anticipate is a good way to create interest and keep your viewer engaged throughout the film.

instant playback – the ability of the videographer to see and review what he/she shoots as it is being shot.

interlaced scanning – a method of displaying moving images in which the odd lines and the even lines of each frame appear alternately.

lavalier mic – a small microphone at the end of a cord that is usually clipped to someone's clothing, close to his or her mouth.

LCD (liquid crystal display) – a flat thin electronic visual display found on the back of your camera, which acts as a viewfinder during video shooting and as a screen on which you can review your footage.

LCD hood – a hood that mounts to the back of your camera over the LCD, or simply attaches to a flip-out LCD. It normally includes a magnifier to allow you to better see the LCD.

LED lights – a type of light used in electronic devices and are now a common and important part of a video shooter's lighting kit, these lights have a very long life, are often balanced to daylight, are never hot, and are energy efficient.

live view – the ability to view exactly what the sensor is seeing in real time.

low angle – a view shot from a very low angle, close to the ground.

luma – the brightness or intensity value of a color video signal, which determines the level of picture detail.

master shot – a main shot that covers all of the action in a particular scene, almost always a wide shot.

medium shot (MS) – a view that often includes both the setting and the subject. Setting becomes less important and relationships between the subject and other nearby subjects or pictorial elements are key. Medium shots emphasize local relationships and action. The relationship between the subject and the setting is emphasized with a wide shot. (See wide shot.)

megapixel (MP) – a measure of 1 million pixels. Megapixels are often used as a standard of resolution for digital imaging. HD video operates with two standards of resolution, 1920 x 1080 or 1280 x 720. The megapixel equivalent is approximately 2MPs for the 1080 standard, and 1MP for the 720 standard.

monopod – a one-legged camera support, usually with a multi-positional head, that can be thought of like one leg of a tripod. (See tripod.)

morph – a transition that merges and changes the image of the outgoing clip into the image of the incoming clip. This transition is often used in fantasy or surreal films, and often gives the appearance of one person turning into another.

motion – a change of the position or location of an object with respect to time.

movement sequencing – a method of sequencing video clips based on the movement from one clip to another. This can include literal movement of your subject throughout the clips, or the movement of the camera to a different perspective.

narrative sequencing – a method of sequencing clips based on the idea of having a beginning, middle, and end to the sequence to communicate a narrative or story.

neutral density (ND) filter – a filter that reduces the intensity light coming into a lens. These filters allow the videographer more flexibility with regards to exposure when shooting in situations with too much light.

output – term referring to the final display of the video. An editor must be conscious of the form that a video will take in its final output.

pace – the impression of speed or tempo through a series of clips, normally affected by both the action within the shots and how quickly different shots are changed.

panning – the action of moving the camera from left to right (or right to left) across the scene. This can be done to follow a subject through the scene, or to give movement to an otherwise static scene.

progressive scanning – a method for capturing and displaying video in which all the lines of each frame appear in sequence.

quartz lights – the most common lighting source for shooting video, these lights come in a range of color temperatures, often between 3200K and 3400K, and can put out consistent light for long periods of time.

QuickTime – Apple's ubiquitous media platform, an extremely flexible file format used for content creation and distribution.

reaction shot – a type of shot that shows the reaction of someone or something to the action that is taking place in the previous shot.

recording media – the form or type of memory or storage that is used to store or record data being capture by the camera.

rendering – the process of creating new frames of video in order to have accurate video playback while editing. Rendering is often needed when applying effects to video.

resolution – the pixel count of a video image; typically for HD video the resolution is 1920 x 1080 or 1280 x 720. Video does not use the dots per inch (dpi) or pixels per inch (ppi) that are used with still photography.

rhythm – the beats or recurring patterns in the sequence, or a regular pattern of transitions between shots.

ripple trimming – the act of lengthening or shortening one clip by pushing the following clips up or down the timeline to compensate.

roll focus – a change of selective focus within the frame while still recording. See selective focus.

rolling shutter effect – the method used by CMOS video sensors to capture a frame of video. Because each row of pixels captures the scene at a different moment in time, scenes with fast motion or a fast-moving camera can create motion artifacts. These artifacts appear as solid objects appearing to bend. In the industry, this is sometimes called "the Jell-O effect."

royalty-free music – music that can be used for video productions that does not need any payment for each use beyond the initial purchase.

selective focus – a way of using shallow or limited depth of field to define, isolate, or emphasize a subject.

sensor – a device that changes an optical image into an electric signal. During video recording the sensor is continuously exposed to light, which is then converted from analog data coming from the sensor into digital data that can be used by digital media devices, including a computer.

sequencing – the process of putting several video clips together in an order.

slide trimming – the act of moving a clip earlier or later in the timeline but keeping its length the same.

slip trimming – the act of adjusting a clip so that its length is the same and that its place in the sequence is the same, but the actual starting point of the original scene is earlier or later.

snap zoom – a very fast zoom that ends on a specific composition. See zooming.

sound effects – specially selected, created, or enhanced sounds used to emphasize an element in a scene, to represent something that happens off screen, or to even accentuate an edit.

stereo mic – a microphone that uses two elements to pick up sound. One part of the mic records sound to the left and one part of the mic records sound to the right.

swish pan – a fast panning technique. See panning.

tapeless recording – recording video without videotape; video recorded to memory cards, hard drives, or discs.

tilting – the action of moving the camera from top to bottom (or bottom to top) through the scene.

timecode – a time stamp for each video frame that is automatically created on some cameras and embedded in each video file. For cameras that don't record timecodes, such as D-SLRs, editing software will treat each clip as if the timecode starts at zero.

transition – a method of segueing between two clips, video and/or audio, on a timeline. A transition can be quick and simple, like a jump cut, or many frames long, like a dissolve. Transitions can include effects like flash frames, swish pans, or blurs.

trimming – the action of cropping the beginning and end of your video clips in order to remove unnecessary footage. This will leave you with only the parts of the shots that are essential to your story, and allow you to sequence remaining clips together more smoothly.

tripod – a three-legged tool used often in photography and videography for the stabilization of the camera. This tool is essential for the creation of sharp images and steady movement throughout video scenes.

trucking – a side-to-side movement of the entire camera, done intentionally to create movement throughout the scene.

video clip – a short piece of a much longer video. This is important to the editing process, as the final video will be composed of a series of video clips.

video format – the specification of the movie file detailing, among many things, the recording medium, resolution, frame rate, bit rate, audio sampling rate, audio channels, etc.

video frame – one of many still images that will compose the final moving picture.

video head – a type of tripod head used for video recording that offers smoother, more fluid movement than a conventional tripod head. Also called a fluid head.

visual sequencing – a method of sequencing your video clips visually. This means that your video clips may not have to be in order of time, as long as you can connect one to the next visually. This may mean that the clips will be similar in color, shape, and motion, of shot type.

visual syncing – a method of syncing an audio clip to a video clip, in which the editor must find an action in the video that has a sound associated with it, and then find that matching sound in the audio recording in order to align the two.

wide screen – often refers to the aspect ratio of 16:9 (see Aspect ratio), which is the most common aspect ratio for HD video.

wide shot (WS) – a wide view of a scene, which establishes a large setting or environment. This type of shot is often called an establishing shot because it may set the stage for your subject and perhaps the whole video.

Windows Media (WMV) – Microsoft's ubiquitous PC media platform, a file format used for content creation and distribution.

windscreen – a screen, placed over a microphone, that protects against wind, greatly reducing the abrasive sound of the wind from the audio track.

wireless mic – a microphone and transmitter that sends the audio signal wirelessly to a receiver attached to the camera or audio recorder.

XLR connector – a large, rugged audio connector that is used in professional audio equipment to connect microphones and other audio devices.

zooming – a method of changing the magnification of a scene onto the sensor with the use of a lens that has variable focal lengths (zoom). This can alter the magnification of the scene within the same shot.

HD VIDEO INDEX